black + white and TWO-COLOR DESIGN

First published in the United States of America by
Rockport Publishers, Inc.
33 Commercial Street
Gloucester, Massachusetts 01930-5089
Telephone: (978) 282-9590
Facsimile: (978) 283-2742

Distributed to the book trade and art trade in
the United States by
North Light Books, an imprint of
F & W Publications
1507 Dana Avenue
Cincinnati, Ohio 45207
Telephone: (800) 289-0963

Other distribution by
Rockport Publishers, Inc.
Gloucester, Massachusetts 01930-5089

ISBN 1-56496-596-1

10 9 8 7 6 5 4 3 2 1

Design: Stoltze Design
Cover Image: Chris Reese

Printed in China.

graphicIDEA
resource

GLOUCESTER MASSACHUSETTS

ROCKPORT PUBLISHERS

black and white and TWO-COLOR DESIGN

Working with Black-and-White and Two-Color Design

Lesa Sawahata

black-and-white and

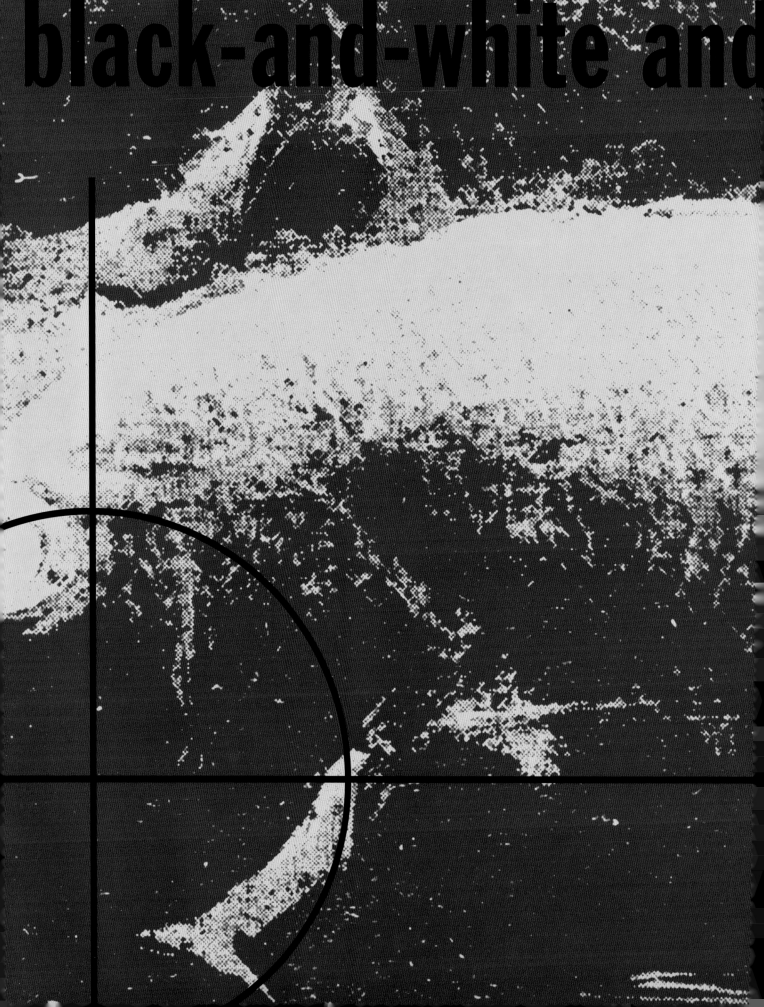

TWO-COLOR DESIGN

In the nineties, many areas of design—including fashion, home interiors, garden, and furniture—have evidenced a paring down to simple, workable solutions. Nowhere is this trend more apparent than in graphic design. Even while technology has provided exciting and expansive new means to create compelling, complex images, type, and layout (not to mention the development of new inks, varnishes, and papers), designers have been thinking in a reductive way. How much can be removed from a design, they seem to be asking, and still have it remain strong and full of impact?

Color—along with its attendant, expensive printing processes—is often the first thing to go. Stripping away color has become a sort of crucible for design with this less-is-more approach actually demanding stronger elements from the designer. Type, images, illustrations, and headlines all gain more importance and must be conceptually cohesive.

While reduced-color design is often less expensive to produce (though reproducing a black-and-white photo on a shopping bag may require four- or six-color printing), it is as miraculously adaptable as the proverbial little black dress; it can run the gamut of style, from restrained elegance to comic-strip boldness. With well-thought-out design, even pieces created on a copying machine can look innovative, rather than cheap and dirty.

An interesting offshoot of this flexible, restrained aesthetic is that black-and-white and two-color design is a popular choice, even in online media where the term *two-color* is meaningless and trendy online magazines maintain a referential, if tongue-in-cheek, connection to print media.

Compiled here are examples of the freshest, least-conventional approaches to limited color design—from simple black-and-white mailers alerting recipients to a gallery opening, to exquisitely, expensively produced shopping bags that unemphatically imply good taste.

Design Firm *Alphabets in-house*
Art Director *Linda Heidinger*
Designer *Peter Samarin*

These shopping bags and postcards for a gift shop in New York reflect the bold, distinctly urban nature of its location: Manhattan's hip, hardcore Alphabet City on the lower East Side. The design calls for direct, unembellished color with red and black being an obvious choice.

TAYLOR GUITARS HANG TAG

Design Firm *Mires Design*
Creative Director *Mires Design*
Art Director *Scott Mires*
Designers *Miguel Perez, Scott Mires*
Illustrators *Miguel Perez, Scott Mires*
Photographer *Miguel Perez*

A hang tag in the shape of a guitar pick is a simple, direct idea for a guitar manufacturer. Musicians can't help looking at the tag-as-pick, which details special features of the instrument. Executed in a single color, this is an economical choice as well as an innovative one.

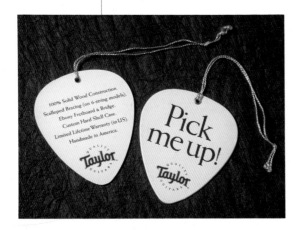

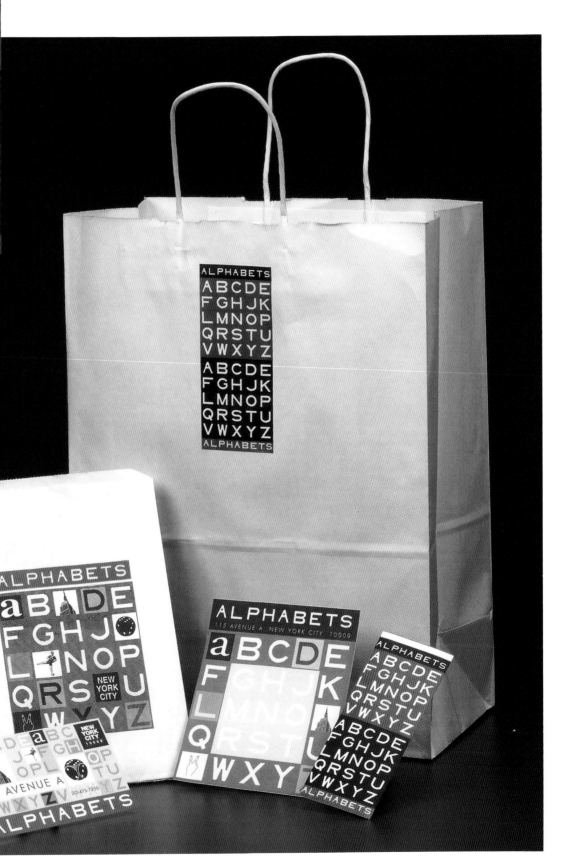

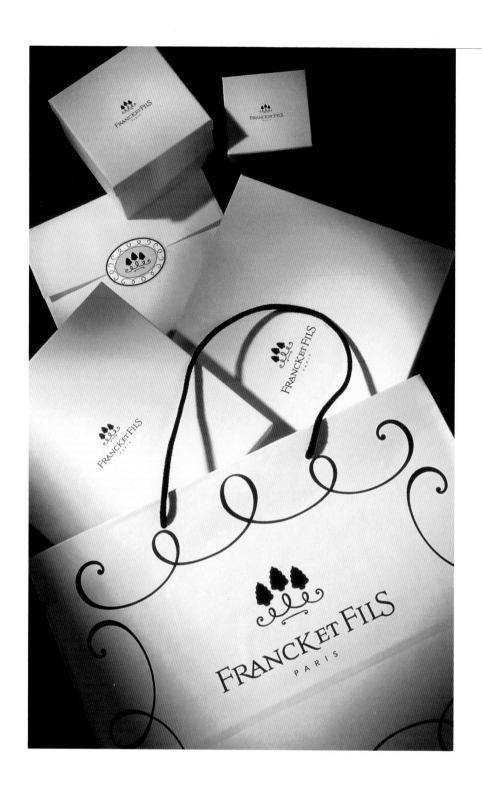

FRANCK ET FILS SHOPPING BAGS AND BOXES

Design Firm *Carré Noir*
Art Director *Beatrice Mariotti*
Designer *Beatrice Mariotti*

Two-color design need not feel or be inexpensive. With these shopping bags and boxes, the elegant curvilinear design motif and traditional typeface recall the wrought iron of Paris, while an energetic yellow reflects the refinement and spirit of the company.

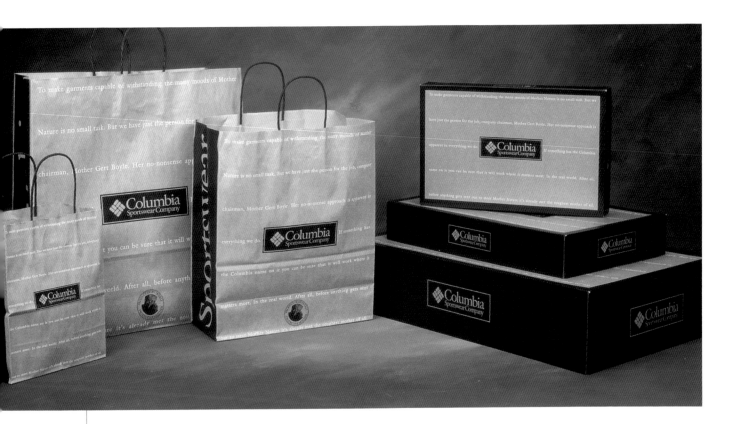

COLUMBIA SPORTSWEAR SHOPPING BAGS AND BOXES

Design Firm *Borders, Perrin, and Norrander*

Kraft paper makes a rugged statement about this outdoor-clothing company; the simple, classic typeface and logo in black add a dignified, stable feeling to this design.

SEAMAN SCHEPPS SHOPPING BAG

Design Firm | *Seaman Schepps in-house*

A basic-black shopping bag depends upon texture—and in this case, a tasteful touch of gold stamping and embossing—to subliminally define its target market. The heavy paper and expensive processes involved in producing this bag mark it as definitely upscale.

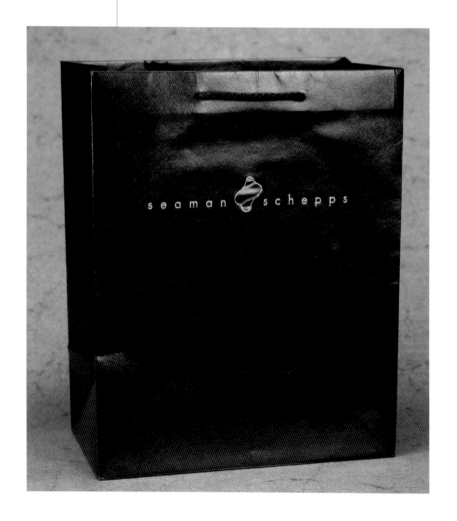

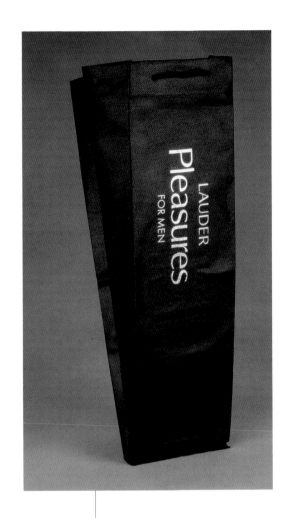

LAUDER PLEASURES FOR MEN SHOPPING BAG

Design Firm | *Estée Lauder in-house*

In marketing toiletries to men, black is a sophisticated
choice—not too flashy or vain. Here, simple, white
lettering on a textured polypropylene bag implies the
deep, low-key pleasure of a new fragrance.

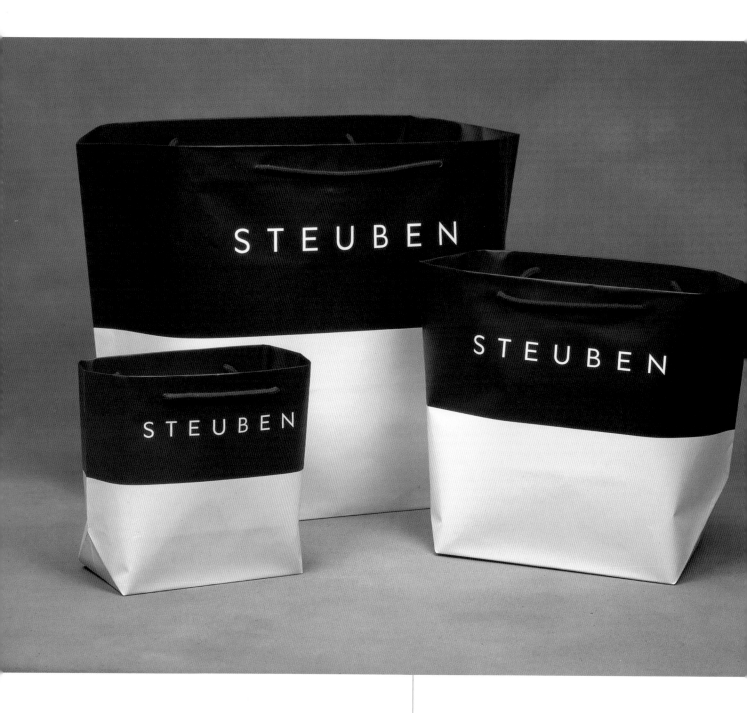

STEUBEN SHOPPING BAGS

Design Firm | *Matsumoto Incorporated*
Designers | *Takaaki Matsumoto, Tina Gianesini*

Elegant, traditional, and solid as a piece of Steuben
glass—that's the feeling conveyed by these two-color
bags, which are shaped like old-fashioned apple-picking
satchels. Matte finish adds to the bags' restrained
good taste.

YELLOW RAT BASTARD SHOPPING BAG

Design Firm | *David Abergel, YRB*

The rough, rugged relief-style type and cartoonish rat logo of this shopping bag are neatly paired with a yellow often used for street signs. Together they signal the urban trend towards streetwear purveyed by YRB.

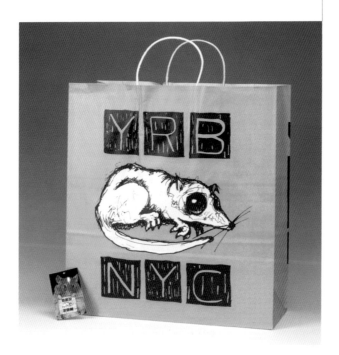

SAKS FIFTH AVENUE SHOPPING BAG

Design Firm *Saks Fifth Avenue in-house*

White, black, and tones of gray are used to define a
familiar logo. This limited color palette creates a
simple, reserved design that needn't shout high end, as
Saks Fifth Avenue shoppers are well familiar with the
department store's elegant wares.

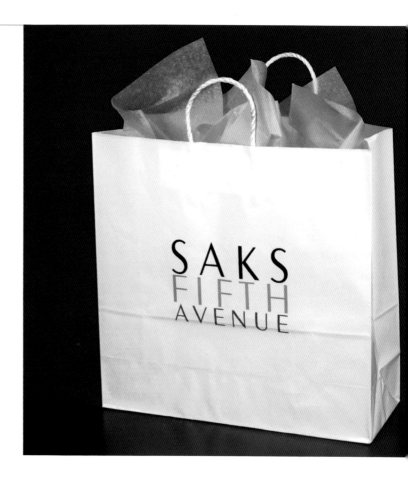

VIVIENNE TAM SHOPPING BAG

Design Firm | *Vivienne Tam in-house*

This magnificently simple shopping bag implies a
combination of urban sophistication and exclusivity
(it was distributed to customers in the designer's
Japanese and NYC boutiques), and alludes to the
designer's Asian heritage with a red ribbon closure.

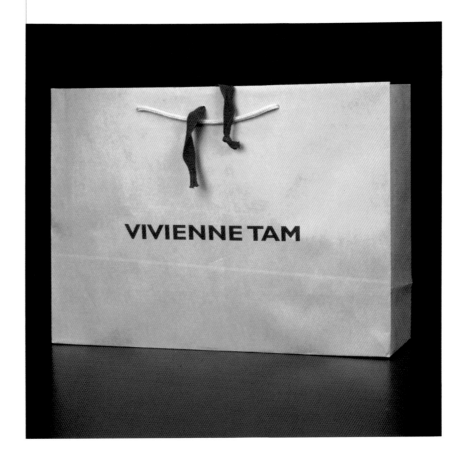

MONDI SHOPPING BAG

Design Firm | *Mondi in-house*

An almost overwhelming sense of desire is created
with this shopping bag. Every element has been chosen
to make a stronger whole, including the model's direct
gaze; the unusual cropping of the photo; the tonal
black-and-white image, reminiscent of vintage
Hollywood glamour shots; and the eye-catching,
lipstick-red detail.

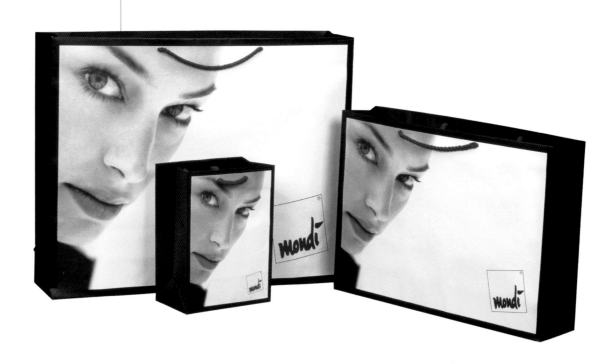

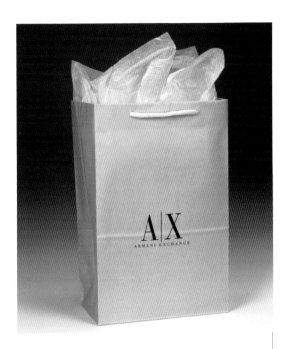

ARMANI EXCHANGE SHOPPING BAG

Design Firm | *Armani in-house*

The basic design of this shopping bag is ideal for the fashion designer's functional, secondary line of clothing. Details make the difference—a rope handle adds elegance while making the bag more comfortable to carry.

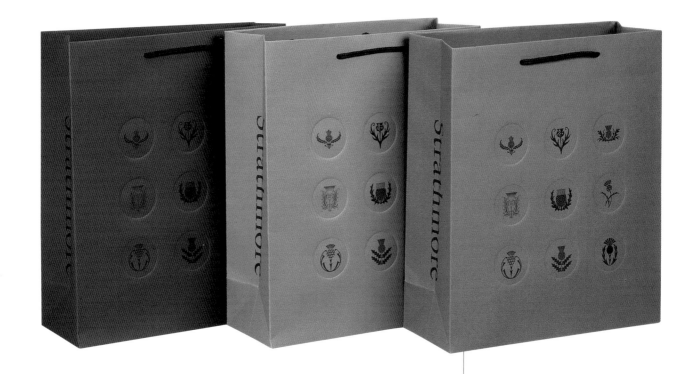

STRATHMORE PAPERS SHOPPING BAG

Design Firm	*Williams and House*
Art Director	*Pam Williams*
Designer	*Michael Gunselman*

A beautiful and creative use of black printing on colored paper was chosen for these bags promoting Strathmore's own Grandee paper. Debossing enhances the texture and rich hue of the paper while variations of the company's trademark thistle become a sophisticated design motif.

I. A. BEDFORD HANG TAG

Design Firm *Sayles Graphic Design*
Art Director *John Sayles*
Designer *John Sayles*

The combination of red with black is always attention grabbing. It is therefore a good choice for projecting a straight-ahead, populist mood, as in this hang tag for sportswear.

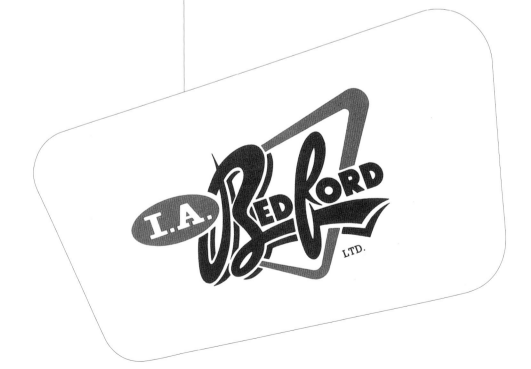

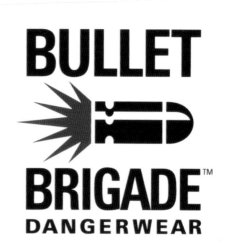

BULLET BRIGADE DANGERWEAR HANG TAG

Design Firm *Bullet Communications*
All Design *Tim Scott*

Another sportswear designer—Bullet Brigade
Dangerwear—chose eye-catching red for the signature
bullet in their logo. The image is so strong that the
hang tag also includes the motto Wear Your
Bullets/Don't Shoot Them to counter any implication
of violence.

WEAR YOUR BULLETS
DON'T SHOOT THEM!

BULLET BRIGADE DANGERWEAR
AND ITS LOGO ARE TRADEMARKS OF
BULLET COMMUNICATIONS, INC./CHICAGO

NATIONAL GEOGRAPHIC SHOPPING BAG

Design Firm | *National Geographic in-house*

The distinctive black typeface and unmistakable yellow logo of the National Geographic Society adds impact to the simple brown paper it is printed on. This bag is used to distribute information to members of the society.

CARIBOU COFFEE SHOPPING BAG

Design Firm | *Caribou Coffee in-house*

This great-looking shopping bag relies upon the texture of natural paper, simple black printing, and a die-cut window and handle to give it an almost architectural look.

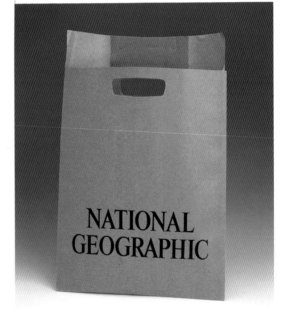

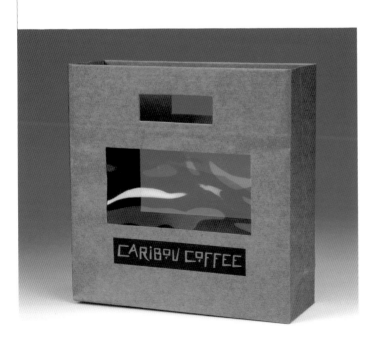

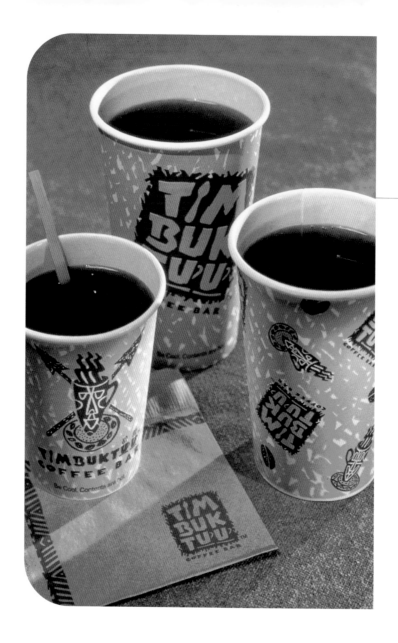

TIMBUKTUU COFFEE BAR PACKAGING

Design Firm | *Sayles Graphic Design*
All Design | *John Sayles*

The coffee boom has opened a whole new retail realm in which to create dashing designs. For such a basic beverage, two-color design is a natural choice; it works particularly well on kraft paper giving the tribal flavor of this logo an earthy, back-to-our-roots feeling.

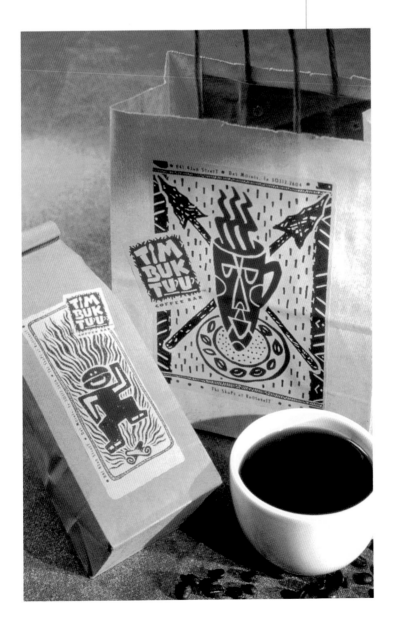

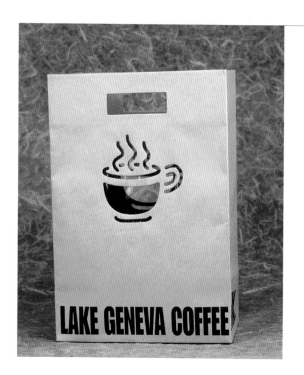

LAKE GENEVA COFFEE SHOPPING BAG

Design Firm *Lake Geneva Coffee in-house*

A simple line drawing of a steaming cup of coffee is die cut into this bag made of heavyweight, natural kraft paper. The straight-ahead black type adds to the direct, cozy charm of the piece.

THE EGG & I RESTAURANT CARRYOUT BAG AND BOX

Design Firm *The Egg & I in-house*

One-color printing can convey the familiar, down-home delights of a traditional picnic meal, as in this packaging for a carryout restaurant, which features a laminated box that looks like an old-fashioned tablecloth.

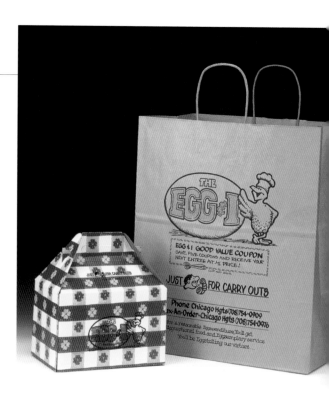

DOSKOSIL INC. DIRECT-MAIL PIECE

Design Firm | *Greteman Group*
All Design | *James Strange*

This distinctly retro-style direct-mail piece about pizza toppings engages the recipient with a bold, two-color design derived from the 1950s. That simpler time speaks to the wholesomeness Doskosil wants to convey.

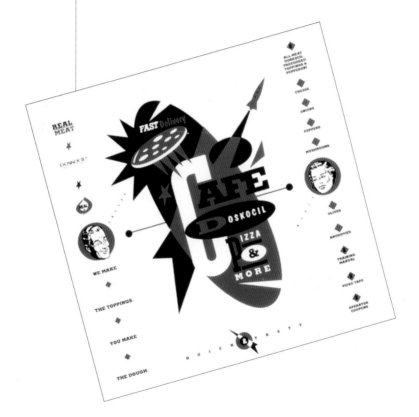

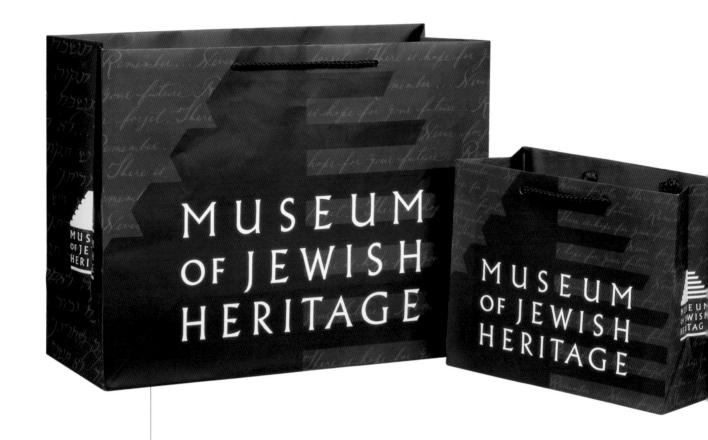

MUSEUM OF JEWISH HERITAGE SHOPPING BAG

Design Firm *Grafik Communications, Ltd.*
Art Director *Judy Kirpich*
Designers *Gretchen East, David Collins*
Calligrapher *Lillie Lee*

The deep midnight blue of these shopping bags implies
faith, resilience, and memory, reinforcing the text that
is part of the bag's design. The quotation, written in
Hebrew and English, says "Remember ... Never forget.
There is hope for your future."

LE CORBUSIER SHOPPING BAG

Design Firm | *Package Land Co. Ltd.*
Art Director | *Yasuo Tanaka*
Designer | *Yasuo Tanaka*

The design for this shopping bag incorporates the
round glasses and bow tie identified with Le Corbusier,
one of the most influential designers of our century.
The shadow added to the simple black-and-white design
lends a sense of three dimensions to the piece.

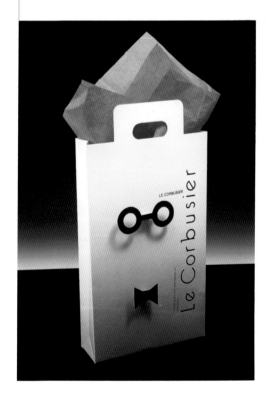

MARK CROSS PACKAGING

Design Firm *Desgrippes Gobe & Associates*
Design Director *Frances Ullenberg*

Two color isn't chosen for its cost effectiveness in this divinely simple, upscale packaging for Mark Cross accessories that employs a varnished silver with black.

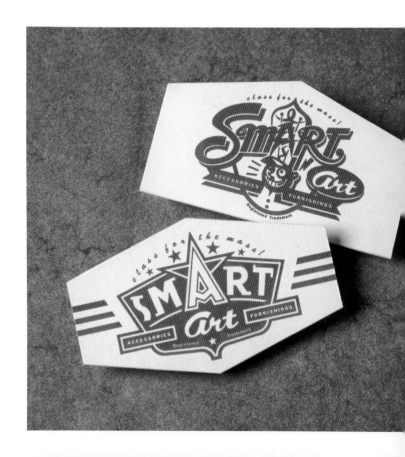

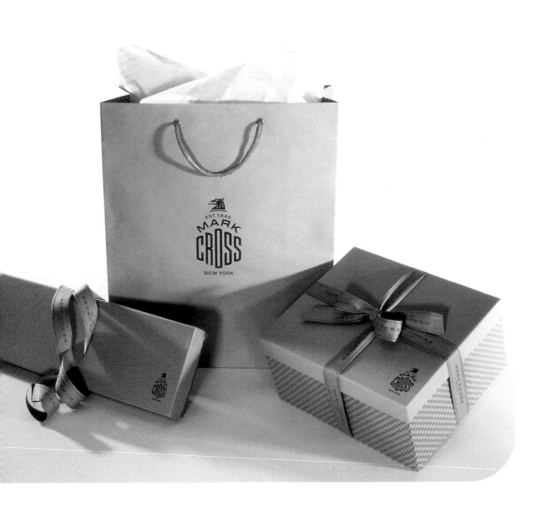

SMART ART TAGS

Design Firm	*Sayles Graphic Design*
Art Director	*John Sayles*
Designer	*John Sayles*

The tags, with their distinctive shapes, include
retro-style logos that have an almost superhero feeling
to them. Printing them in one color is a cost-conscious
choice, using red makes them stand out.

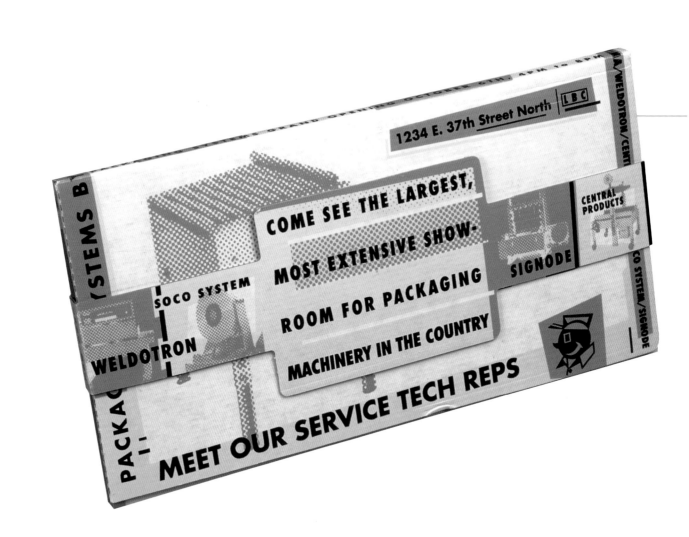

LOVE BOX COMPANY DIRECT-MAIL PIECE AND POSTER

Design Firm *Love Packaging Group*
Creative Director *Mires Design*
All Design *Brian Miller*

This direct-mail piece, which is constructed entirely of
corrugated paper, opens up into a poster. The use of a
slightly faded green and black with retro imagery adds
a warm, service-oriented implication to the piece.

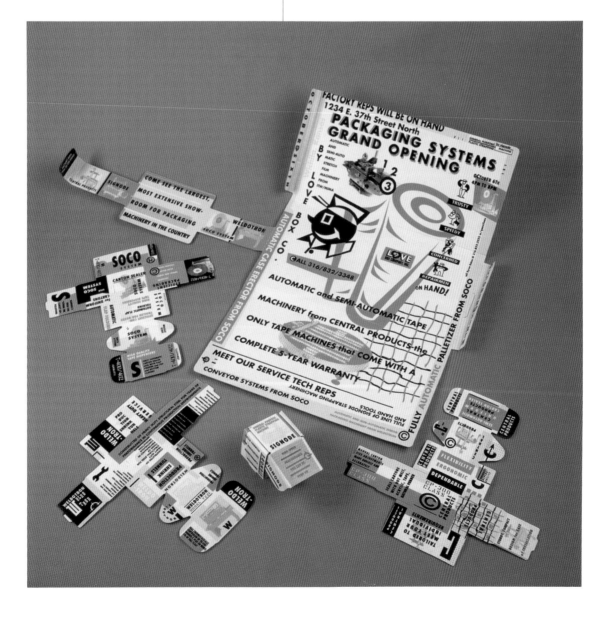

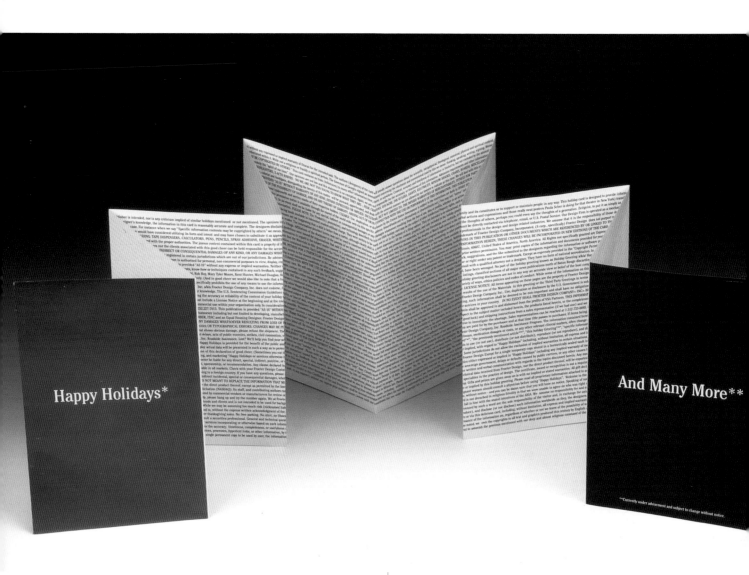

FROETER DESIGN COMPANY HOLIDAY CARD

Design Firm | *Froeter Design Company, Inc.*
Designers | *Tim Bruce, Chris Froeter, Paul Bichler*

In this two-color holiday card, the interior is completely
covered with small-type disclaimers—another instance
where type becomes design. Since the recipient is
clearly not meant to read the inside of the card, the
effect becomes one of texture rather than content.

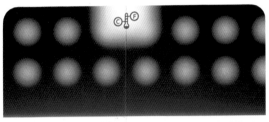

CELSIUS FILMS INCORPORATED

CELCIUS FILMS IDENTITY PROGRAM

Design Firm *Segura Inc.*
Designer *Carlos Segura*

Like looking at a black-and-white film under a microscope—that's the feeling conveyed by this two-color identity program for an independent film company. There is an eerie, film-noir quality to the field of black punctuated by the slightly blurred white circles.

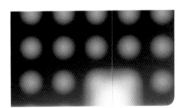

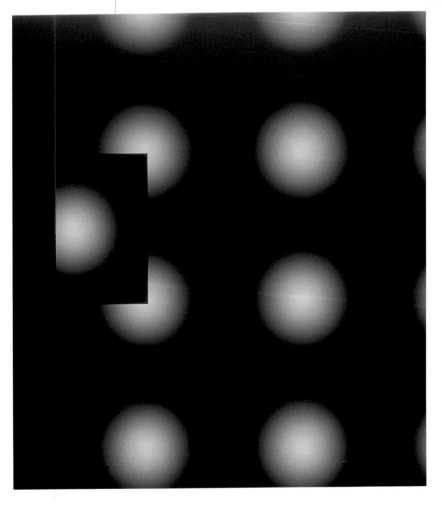

OCULUS NEWSLETTER

Design Firm *Pentagram Design, Inc.*
Designers *Michael Gericke, Edward Chiquitucto*

The bold, urban graphics of this newsletter, which is published by the New York branch of the American Institute of Architects (AIA), pays tribute to Russian Constructivist design of the 1920s. Red and black further strengthen the look of the publication.

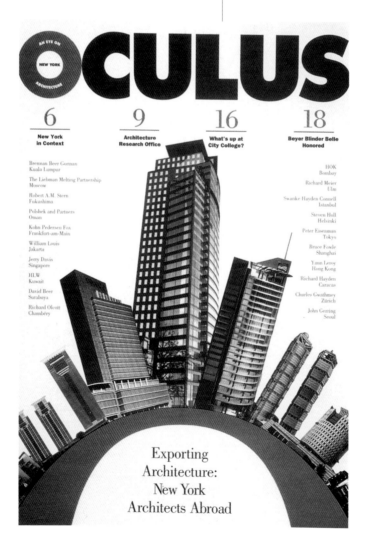

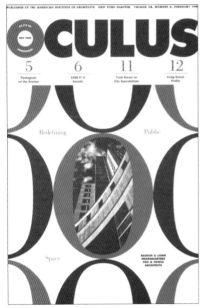

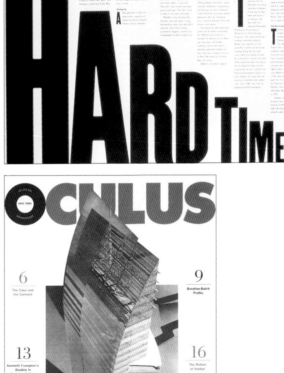

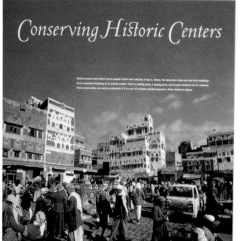

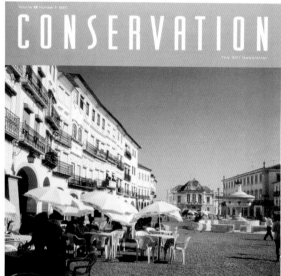

THE GETTY CONSERVATION INSTITUTE
CONSERVATION NEWSLETTER

Design Firm | *Mondo Typo Inc.*
Designer | *Joe Molloy*

This publication is photojournalistic in feel, so that black-and-white photography and printing are a natural choice. An unusual, square format adds further interest to the design of the piece.

JACOR COMMUNICATIONS, INC. 1996 ANNUAL REPORT

Design Firm | *Petrick Design*

This two-color annual report combines strength (its direct text and simple, minimal graphics) and poetry (the choice of translucent vellum paper) to give the sense of layers of sound.

STANT CORPORATION 1996 ANNUAL REPORT

Design Firm | *SamataMason, Inc.*
Creative Director | *Dave Mason*
Designers | *Dave Mason, Pamela Lee*

In this slick annual report for an automotive parts
and tools manufacturer, photography sets the pace.
The product shots are more like glamour shots—even a
grease gun looks like an elegant, desirable object.

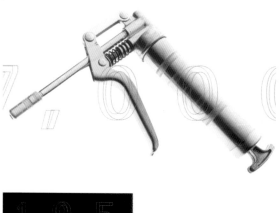

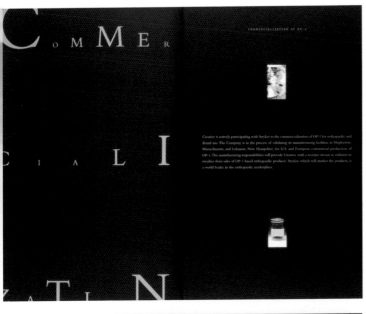

CREATIVE BIOMOLECULES 1996 ANNUAL REPORT

Design Firm | *Weymouth Design Inc.*
Designer | *Thomas Laidlaw*

The elegant use of type and photography make for a
sublimely simple annual report for a biopharmaceutical
company. The breaking up of type on the cover—each
letter taken from the word *creative*—graphically implies
the scientific scrutiny of cells that, when assembled,
make a whole body.

this was the year our flanders street pub was transformed into the second of our full-service restaurants and a fine big place to try *true brews* and listen to live blues.

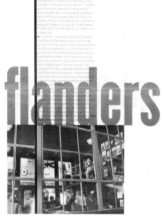

ma

flanders

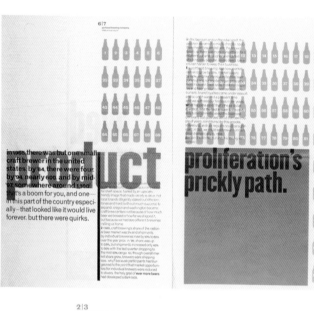

in 1965, there was but one small craft brewer in the united states. by '84, there were four. by '94, nearly 600. and by mid-'97, somewhere around 1,100. that's a boom for you, and one— in this part of the country especially—that looked like it would live forever. but there were quirks.

duct

proliferation's prickly path.

it takes no sherlock to see that '96 was a less rosy year than others we've had at portland brewing. just take a look at the highlights and this straight-up report.

the short 〈**why**〉 story?

well, the market changed on us. while we were ramping up production (along with every other craft brewer), the demand we were chasing suddenly dropped off. the result was from economics 101: supply outpaced demand. conditions changed so fast that, even though we course-corrected, we still turned in a bum fourth quarter. and showed a loss for the year.

we're not whining. mind you. what happened happened and we're dealing with it. matter of fact, as you'll see when we describe **context** (e.g. how other brewers are faring), we're dealing pretty well. our **true brews** – *mactarnahan's amber ale, oregon honey beer, wheat berry brew, haystack black,* our new *zigzag lager,* and the seasonals – are great. our installed capacity is up to 135,000 barrels of full ale production. our processes and controls have improved a bunch, and we work in a great brewhouse.

we like our prospects a lot. but we wanted you to know going in why we sound a little more deliberate this time.

PORTLAND BREWING COMPANY 1996 ANNUAL REPORT

Design Firm | *The Felt Hat*

Printed in two colors, this annual report for a
microbrewery in the Pacific Northwest was printed after
the industry went through an economic dip, so the
designers pursued a bottom-line look—everything from
type style to newsprint is economical and back to
basics. The screen-print design motif is amusing and
includes optimistic references to a glass being half full
rather than half empty.

portland brewing company 1996 annual report

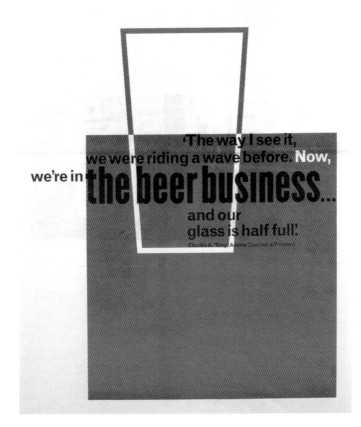

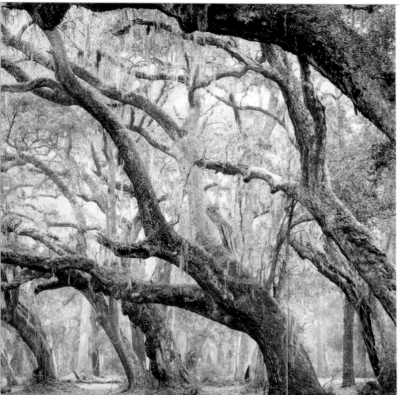

Live Oak Forest, Sapelo Island, Georgia

THE ENVIRONMENTAL PROFESSION is the key to making environmental law work. Since its founding a quarter century ago, the Environmental Law Institute has seen improving the professionalism of this corps of attorneys, managers, and policy makers as critical to achieving society's goals for improving the health of the biosphere and its inhabitants. ❧ The challenge in environmental protection is as much in evolving effective means of reaching goals as in the setting of them. Both the formulation of policy and its execution require an environmental profession that is capable of advancing a field that is as complex in its interrelationships as the ecosystem it addresses. ❧ ELI builds professional expertise through its educational programs and its publications. ELI fosters professional dialogue by serving as a convening forum for all sectors. ELI enhances professional ethics by working with practitioners to promote the highest standards of practice, and concern for the health of the biosphere and its inhabitants. And ELI is building a global partnership among professionals to help realize the vision of sustainable development.

ENVIRONMENTAL LAW INSTITUTE
ANNUAL REPORT 1996

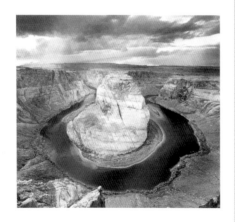

ENVIRONMENTAL LAW INSTITUTE 1996 ANNUAL REPORT

Design Firm | *CartaGraphics Inc.*
Photographer | *Bruce Barnbaum*

The clear, poetic black-and-white photography in this annual report illuminates the overwhelming beauty of the natural world—the world that the Environmental Law Institute was created to protect through legislation, policies, and management.

WOHNFLEX INVITATION CARD

Design Firm | Kommunikations-Design BBV
Creative Director | Michael Baviera
Art Director | Siegrun Nuber
Designer | Siegrun Nuber

In this two-color invitation, type *is* design. The most basic of all typefaces, Helvetica, is used to document the designers of home furnishings that have been shown at Wohnflex since the 1970s.

MABO COMPANY PROMOTION

Design Firm | *Media Artists Inc.*
Art Director | *Michael Connell*
Designer | *Joe Connell*

In a subdued promotion for a button manufacturer, the designer made choices that countered the colorful nature of the product and instead highlighted the company's philosophy of quality and customer service.

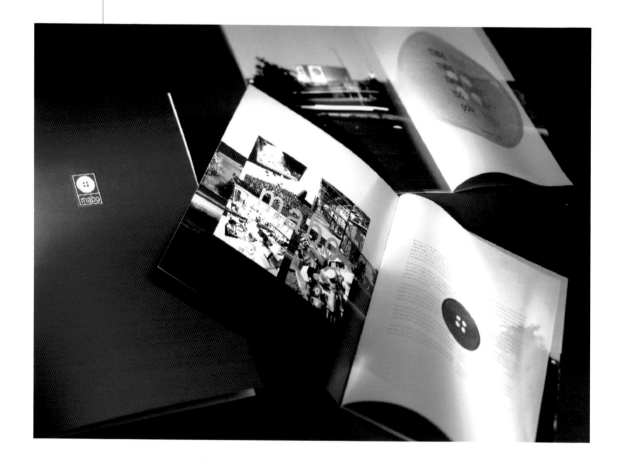

it's about *people*,
not technology.

how people feel and what
they believe determines
what they will buy. *attitudes
determine* behavior. hint:
look for unrecognized human
needs. use them to create
new territory you can own.
the *answer* lies in leveraging
simple human emotions.

some things are beyond words.

GVO IDENTITY BOOK

Designer | *Ken Probst*

The most innovative approach to design may well be to
make a project look undesigned. In this black-and-
white identity book, lowercase type has been processed
by fax and photocopier to give it a worn, distressed look.

THE BLACKSTONE GROUP CAPABILITIES BROCHURE

Design Firm *Carbone Smolan Associates*
Designers *John Nishimoto, Karla Henrick*

The facts, in black and white, are presented by this
capabilities brochure for a financial-services company.
While imagery is purposely limited, the colors, com-
bined with the rich textures of the chosen papers,
enhance the effect of quiet prosperity.

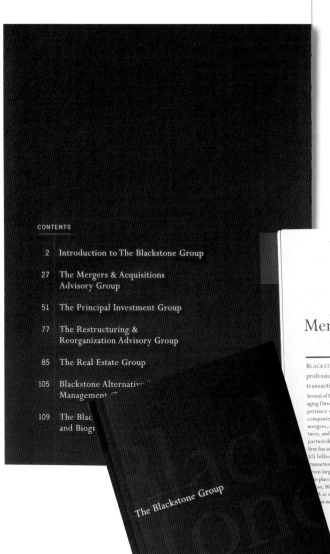

CONTENTS

The Blackstone Group

We must evolve constantly,
moving our thinking, practice,
and personnel to where

THE BLACKSTONE GROUP

Blackstone's
Japan/Asia
Mergers & Acquisitions
Capability

BLACKSTONE HAS DEVELOPED an experienced group of
professionals dedicated to advising on trans-Pacific M&A
transactions.

Several of Blackstone's Senior Man-
aging Directors have extensive ex-
perience working with Japanese
companies on a wide variety of
mergers, acquisitions, joint ven-
tures, and other kinds of business
partnerships. Cumulatively, the
firm has advised on approximately
$15 billion worth of U.S.-Japan
transactions, including three of the
ven largest such transactions to
e place in the last decade. In ad-
on, Blackstone has worked on
A as well as principal transac-
in many other parts of Asia in-

cluding Korea, Thailand, the Phil-
ippines, Hong Kong, China, Singa-
pore, India, and Vietnam.
 More than two dozen M&A
professionals are involved in U.S.-
Japan transactions at Blackstone's
affiliate, Nikko Securities, through
its offices in both New York and
Tokyo. Since 1988, a number of
these professionals have spent years
in New York, working on M&A ad-
visory assignments together with
their Blackstone colleagues before
returning to Tokyo.

Blackstone's **Asia-Pacific** Transaction Highlights

ACQUIRING COMPANY	TARGET OR ACQUIRED COMPANY	FORM OF TRANSACTION	TRANSACTION VALUE ($MM)
Sony Corporation	Multiple acquisitions including CBS Records, Columbia Pictures, Materials Research Corp. and others	Acquisitions	$6,000
Bridgestone Corporation	The Firestone Tire & Rubber Company	Sale	$2,652
Sumitomo Electric Industries, Ltd.	Judd Wire, a Division of High Voltage Engineering Corporation	Acquisition	Not Disclosed
The Nikko Securities Co., Ltd.	Wells Fargo Investment Advisors, a Subsidiary of Wells Fargo & Co.	Acquisition of 50% stake	$125
Boone Co.	Koito Manufacturing Co., Ltd.	Defense	Not Applicable
Kyocera Corporation	Elco Corp., a Unit of Wickes Cos.	Sale	$250
Mitsubishi Corporation (together with Management of Aristech Chemical Corporation)	Aristech Chemical Corporation	Acquisition	$1,000
Mitsubishi Corporation	UCAR Carbon, a Subsidiary of Union Carbide Corporation	Acquisition of 50% stake	$780
Sumitomo Corporation of America	Phoenixcor	Acquisition of majority stake	Not Disclosed

THE BLACKSTONE GROUP CLIENTS ARE SHOWN IN ITALICS.

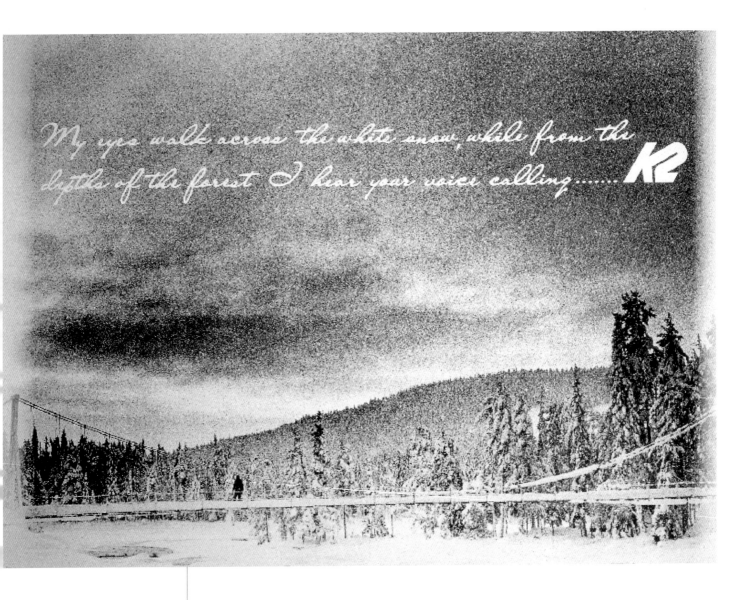

My eyes walk across the white snow, while from the depths of the forest I hear your voice calling....... K2

K2 IMAGE POSTER

Design Firm	Media Artists Inc.
Art Director	Michael Connell
Designer	Michael Connell

This poster runs counter to the more predictable, thrills-spills-and-chills effect often promoted in the skiing industry. The gentle duotone image is well matched with the longing implied by the headline, which that portrays skiing as an almost spiritual pursuit.

CENTRE EUROPEEN DU LASER BROCHURE

Design Firm | *Tangram Strategic Design*
Creative Director | *Enrico Sempi*
Art Directors | *Enrico Sempi, Antonella Trevisan*
Designer | *Antonella Trevisan*

Esthetic surgery—with the emphasis on esthetic—is
the subject of this French brochure, which downplays
the surgical aspect of the procedure and concentrates
instead on the beautiful results. This message is
conveyed by the soft, sensuous photography and
graceful type.

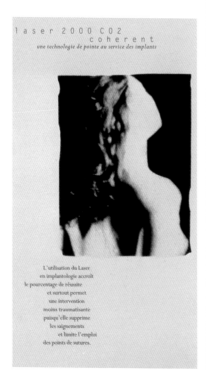

laser 2000 CO2
coherent
une technologie de pointe au service des implants

L'utilisation du Laser
en implantologie accroît
le pourcentage de réussite
et surtout permet
une intervention
moins traumatisante
puisqu'elle supprime
les saignements
et limite l'emploi
des points de sutures.

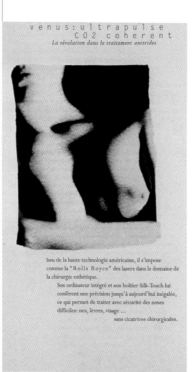

venus:ultrapulse
CO2 coherent
La révolution dans le traitement antirides

Issu de la haute technologie américaine, il s'impose
comme la "Rolls Royce" des lasers dans le domaine de
la chirurgie esthétique.
Son ordinateur intégré et son boîtier Silk-Touch lui
confèrent une précision jusqu'à aujourd'hui inégalée,
ce qui permet de traiter avec sécurité des zones
difficiles: nez, lèvres, visage ...
sans cicatrices chirurgicales.

beauté: les
traitements laser
anti-âge

Le M 300,
dont est équipé le Centre,
est un Laser Helium Néon
à diodes infrarouges et se situe
dans la catégorie des soft Laser.

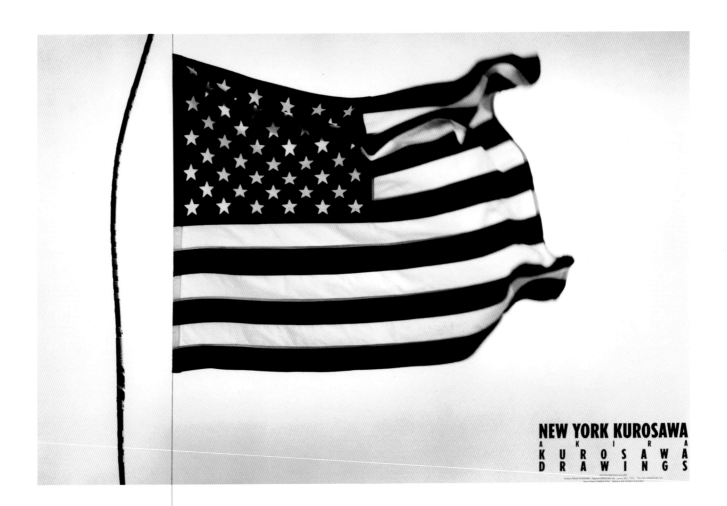

ISE CULTURAL FOUNDATION EXHIBITION POSTER

Design Firm | *Toda Office*
Designer | *Seiju Toda*

Removing color may be the most elegant solution for joining apparently dissimilar objects. For example, a Japanese bow and the American flag develop a graphic relationship in this poster for a New York–based exhibition of drawings by Akira Kurosawa.

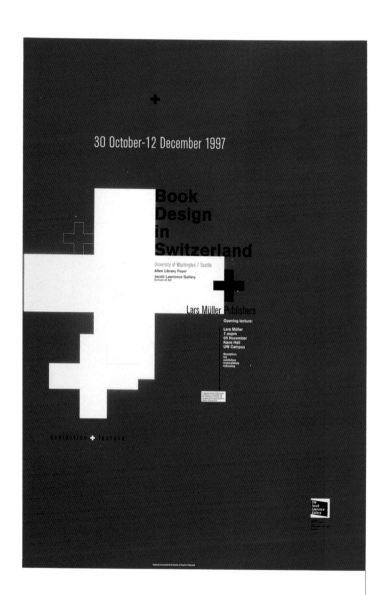

**BOOK DESIGN IN SWITZERLAND/LARS MUELLER
EXHIBITION POSTER**

Design Firm *Studio Ozubko*
Designer *Christopher Ozubk*

The cross, a visual cue taken from the Swiss flag,
becomes the major design element in this punchy
two-color poster for an exhibition on contemporary
Swiss book design.

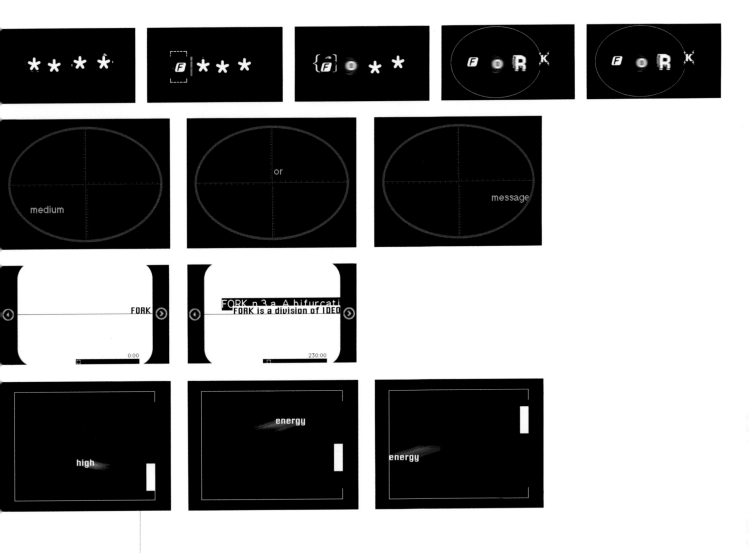

FORK WEB SITE INTERACTABLES

Design Firm | *Fork, a Division of IDEO Product Development*
Designers | *Peter Spreenberg, Dennis Poon*

The reductive color scheme of this Web site allows full concentration to rest on the interactables—animated, intriguing little communication stimulators that the browser must interact with to get the entire message of the site.

**KODJO FRANCISCO AND MIREILLE SMITS
BIRTH ANNOUNCEMENT**

Design Firm | *Mireille Smits*
Illustrator | *Mireille Smits*

This designer, who is accomplished at relief-printed illustration, used the technique to create a very personal birth announcement for her son, Yannick. It is inexpensively photocopied in black on textured paper.

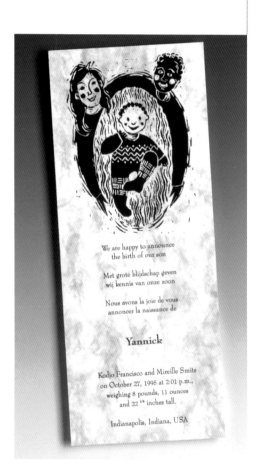

MUSEUM OF MODERN ART CHRISTMAS CARD

Design Firm | *Sagmeister Inc.*
Art Director | *Linda Heidinger*
Designer | *Susanne Poelleritzer*

The ingenuity of die cutting makes this minimal card, which is printed in one color, into a sort of flat sculpture, a perfect choice for the Museum of Modern Art.

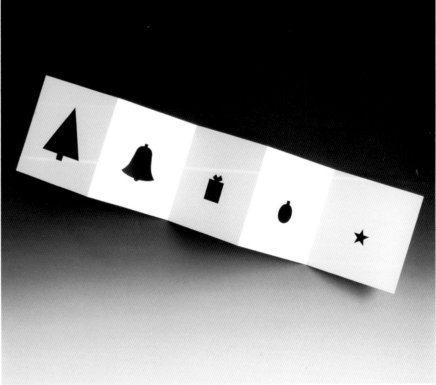

SCHERTLER AUDIO TRANSDUCERS BROCHURE

Design Firm *Sagmeister Inc.*
Art Director *Stefan Sagmeister*
Designers *Stefan Sagmeister, Eric Zim*
Illustrator *Eric Zim*

The sensitive selection of photography, type, and
attention to form—for example, text that is shaped
like a guitar with a page border that echoes the
instrument's curve—shows that black and white can be
the most resonant choice for a brochure. The cover is
a two-color silk screen on chipboard.

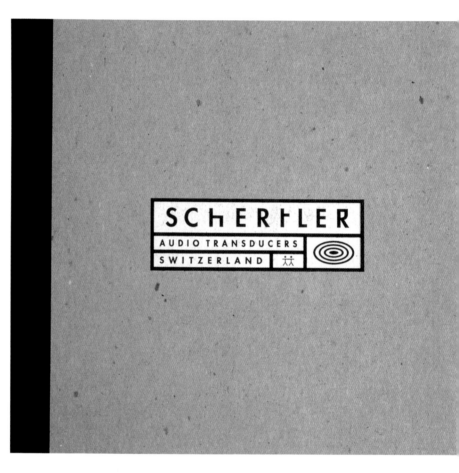

GUITAR
TRANSDUCER

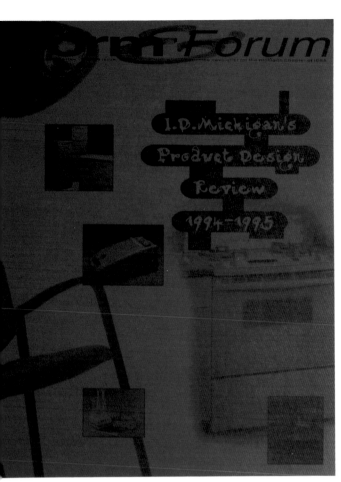

IDSA MICHIGAN *FORM FORUM* NEWSLETTER

Design Firm | *Barry Hutzel*

This clever product-design review maximizes impact and minimizes expense by utilizing black on colored stock for the cover, and printing interior pages in a single PMS color.

DESIGN CENTER POSTCARDS

Design Firm | *Design Center*
Art Director | *John Reger*
Designer | *Sherwin Schwartzrock*

There's something handcrafted about each of these two-color postcards, whether it is hand stapling, punching, or applying a bandage. The extra attention to detail, in addition to the amusing illustration style, adds impact to the project.

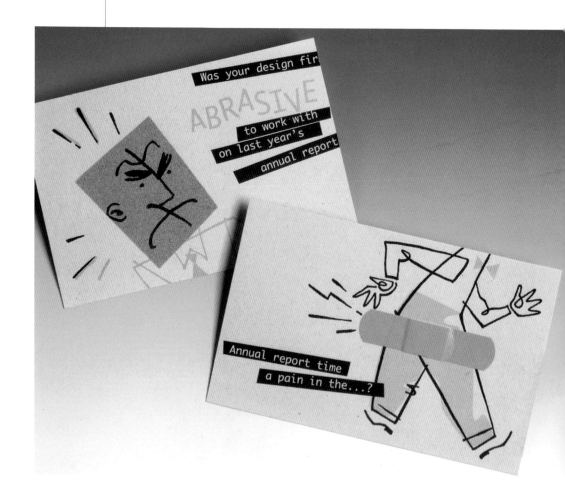

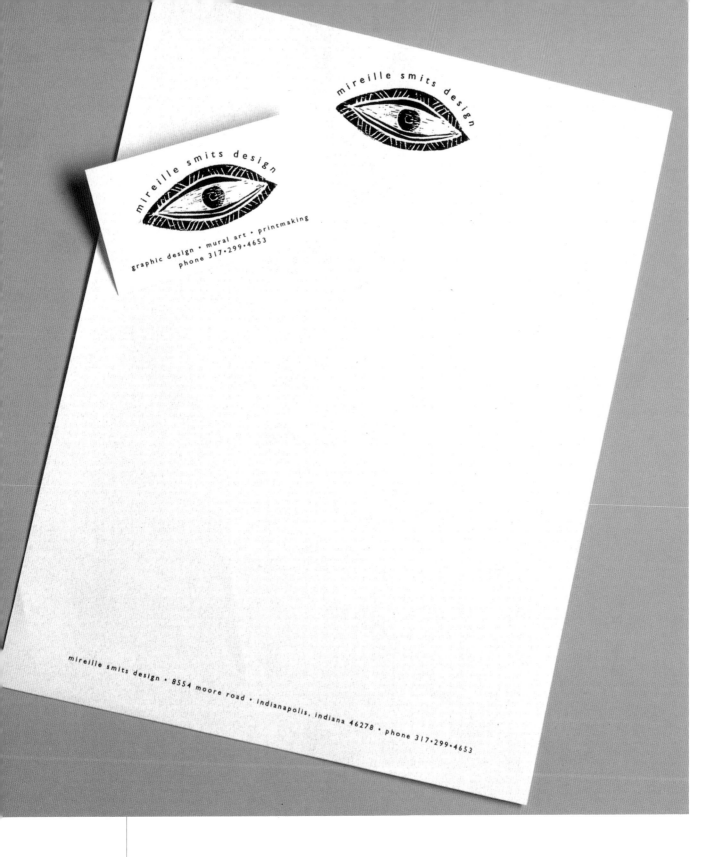

**MIREILLE SMITS DESIGN LETTERHEAD
AND BUSINESS CARD**

Design Firm *Mireille Smits Design*
Illustrator *Mireille Smits*

This designer created a woodcut that indicates she
has an eye for design, to serve as her logo. Depending
on the occasion, her letterhead and business card can
be photocopied onto whatever paper stock she chooses.

DHA (USA) IDENTITY PROGRAM

Design Firm	*Sagmeister Inc.*
Art Director	*Stefan Sagmeister*
Designers	*Stefan Sagmeister, Eric Zim*
Photographer	*Tom Schierlitz*

This project, executed entirely in black and white, was ingeniously designed to be completely free from type— all required text is part of the photographs used in this identity program.

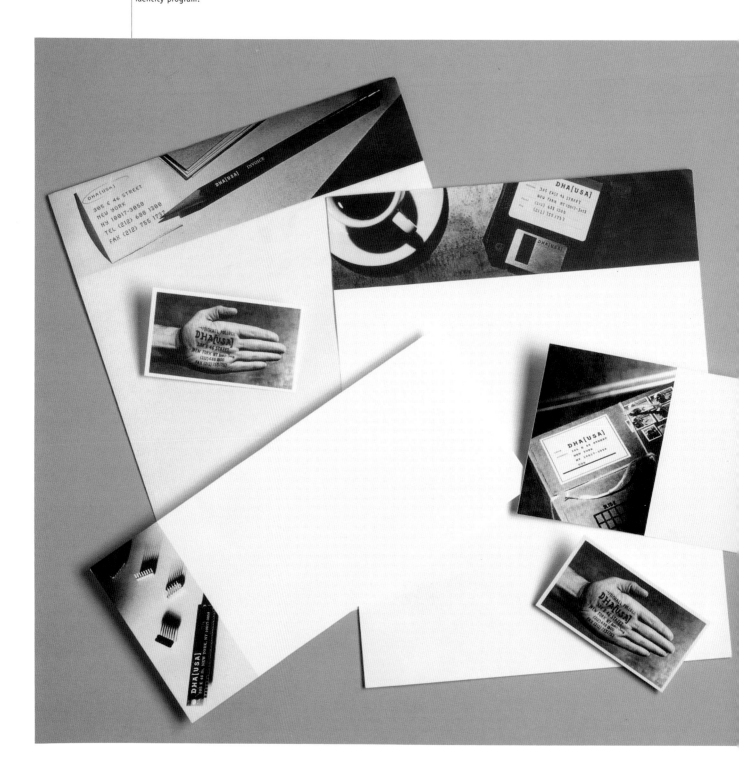

THE TIDES IDENTITY PROGRAM

Design Firm | *David Carter Design Associates*
Art Director | *Lori B. Wilson*
Designer | *Kathy Baronet*

Corrugated paper is a graphic realization of ocean
waves, which are affected by the tides. Two-color
printing on several colors of text stock allowed the
logo to be embossed for a clean, contemporary look.

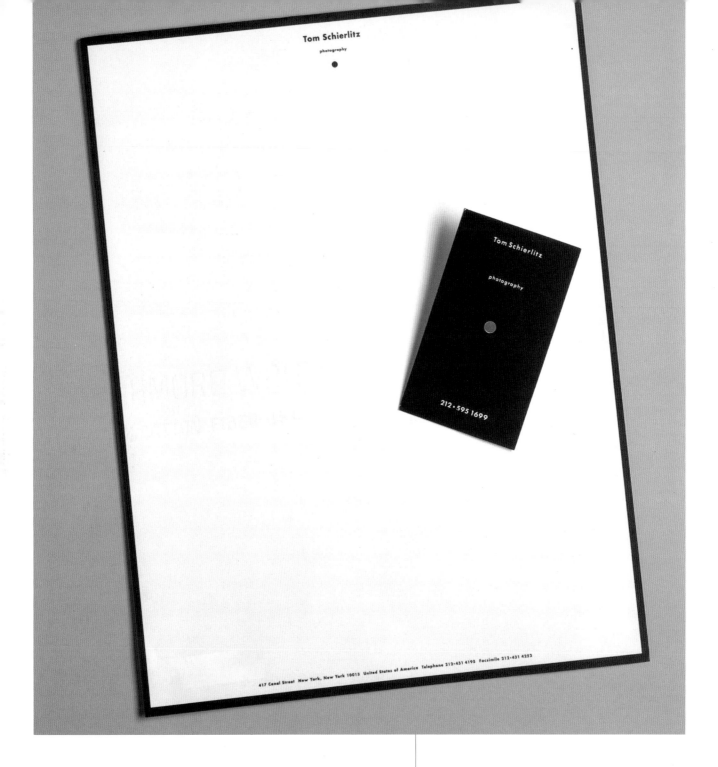

TOM SCHIERLITZ LETTERHEAD

Design Firm | *Sagmeister Inc.*
Art Director | *Stefan Sagmeister*
Designer | *Stefan Sagmeister*

The peephole die cut in the center of this photographer's business card implies a good—if furtive—eye. The plain, almost somber, black-bordered letterhead suggests his accomplished use of black-and-white photography.

RANDOM BUS IDENTITY PROGRAM

Design Firm | *Sagmeister Inc.*
Art Director | *Stefan Sagmeister*
Designers | *Stefan Sagmeister, Eric Zim*
Photographer | *Tom Schierlitz*

Photographs of a moving bus, taken from various angles, help reinforce the idea that this company is moving and shaking. The simple, almost Bauhaus design is ideally realized in black and white.

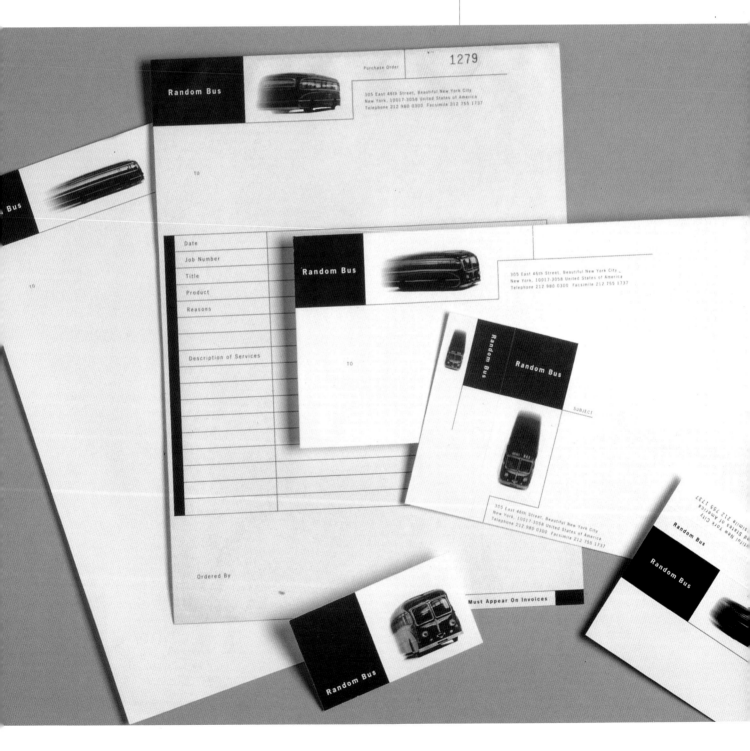

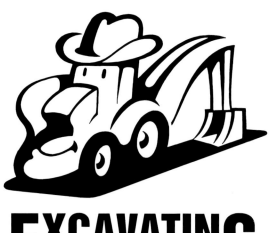

DENNIS MARCHANT EXCAVATING LOGO

Design Firm | The Weller Institute for the Cure of Design
Art Directors | Don Weller, Cha Cha Weller
Designer | Don Weller
Illustrator | Don Weller

This logo, executed in black, is so accomplished it requires no color whatsoever. The simple block letters give the history of the company, while the image describes not just what, but who, is central to the business.

SANTORO FAMILY BIRTH ANNOUNCEMENT

Design Firm | *Worksight*
Designer | *Scott Santoro*
Photographer | *Scott Santoro*

The use of colored parchment paper adds exactly the right texture to enrich this simple birth announcement, which features a clever illustration, screen tinting, and a single PMS color.

hello emily and scott. this is glenn calling. i'm leaving this message to update you on the correct information for the erik, i mean GREGORY birth announcement. the time of birth is

8:44am

...not 9:00 am. the rest of the information is correct. the date is september 12, 1992. the weight is 7lbs 1.9 ounces, the length 19½ inches and the name— GREGORY JOSEPH SANTORO. i hope this adds to your artistic endeavor, and thanks from marianne, erik, GREGORY and me. talk to you later.

m, e, G + g, 36 noel lane forestville connecticut 06010

design: emily + scott santoro

HUTZEL 1996 CHRISTMAS CARD

All Design *Barry Hutzel*

Holidays are the time of year when family is foremost
on our minds, a fact used to advantage by this small
design firm. The pages were created on a laser printer,
the stock was donated or leftover, and the Hutzels
assembled each piece by hand.

WORKSIGHT MAGNET CARD

Design Firm *Worksight*
Designer *Scott Santoro*
Photographer *Scott Santoro*

A magnet that looks like an industrial drawing was this
design firm's holiday gift. It was mailed out on a card
that included a layer of metal plus a cardboard backing.

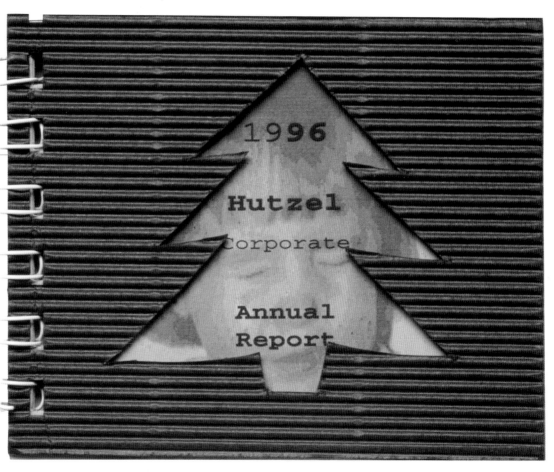

What Paige is thankful for

8

• I am most thankful for God, fun with my family, friends and myself

• I am thankful for the special friendship I have with my old neighbor Mary

• My Cinderella and ballerina costumes

• All my pens, pencils, markers and crayons

• All the different papers Daddy brings home to use my pens, pencils, markers and crayons on

What Eden is thankful for

9

• I most tanful for my happy buthday to you

• I tanful for TV and videos and Toy Sory and Fuzz and Woodey and Aladin and Beutey&Beas and the Lion King

• I really happy for Diapers

• Goofy Goofy Goofy

• My blankey

• My "Baa" at the end of the day

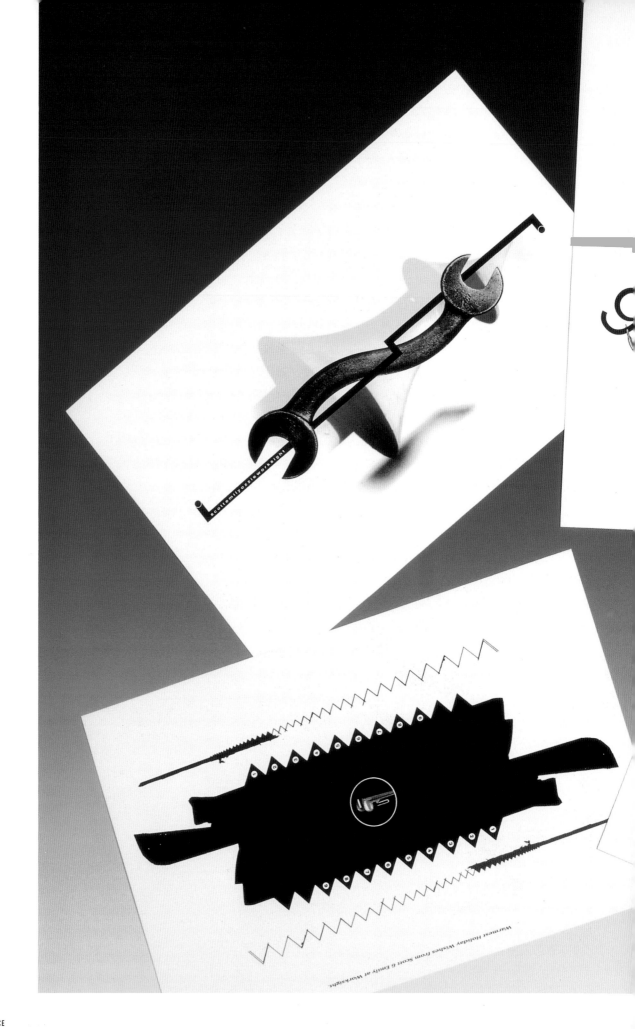

scottemilyozzieworksight

Warmest Holiday wishes from Scott & Emily at Worksight

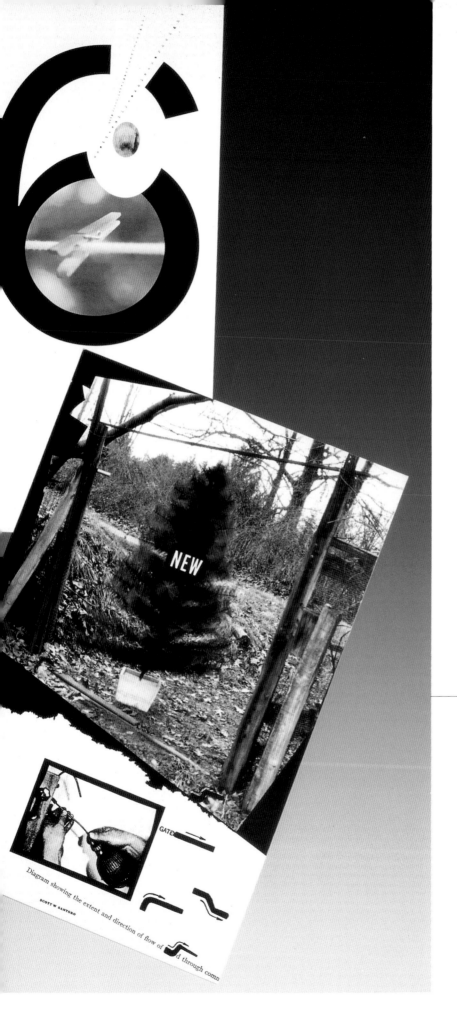

WORKSIGHT GREETING CARDS

Design Firm *Worksight*
Designer *Scott Santoro*
Photographer *Scott Santoro*

Ingenious design on a low budget is the essence of these greeting cards, which feature photos that were shot and manipulated by the designer and then printed either in black or black with one PMS color.

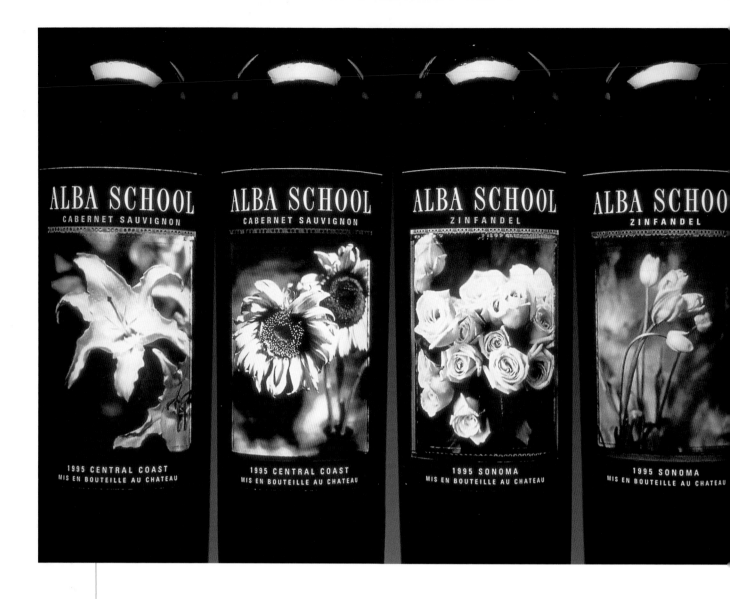

SKELETON KEY CD

Design Firm *Sagmeister Inc.*
Art Director *Stefan Sagmeister*
Designers *Stefan Sagmeister, Veronica Oh*
Illustrators *Stefan Sagmeister, Erik Sanko*

Black and white becomes dynamic and exciting in this packaging for a CD. The stamp motif, which is continued on the CD itself, includes cancellation marks that are actually the titles of songs.

ALBA SCHOOL WINERY LABELS

Design Firm *Charney Design*
Art Director *Carol Inez Charney*
Designer *Carol Inez Charney*
Photographer *Susan Friedman*

The moody, poetic beauty of the photography on these wine labels is enhanced by a limited wash of color. Using a Scitex Spontaine color proofer, they were printed directly onto adhesive label stock.

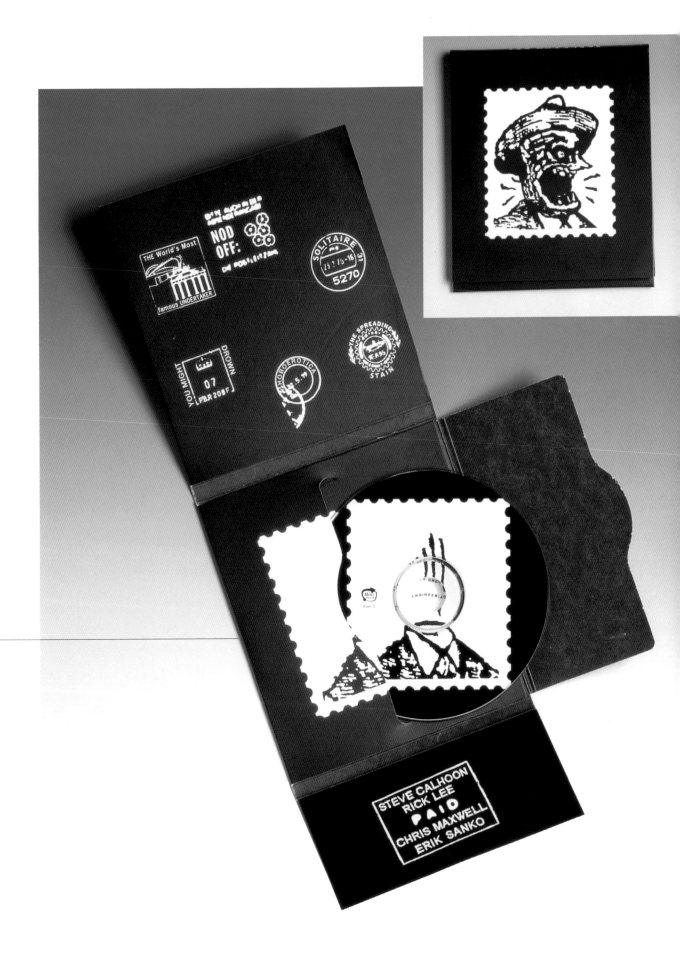

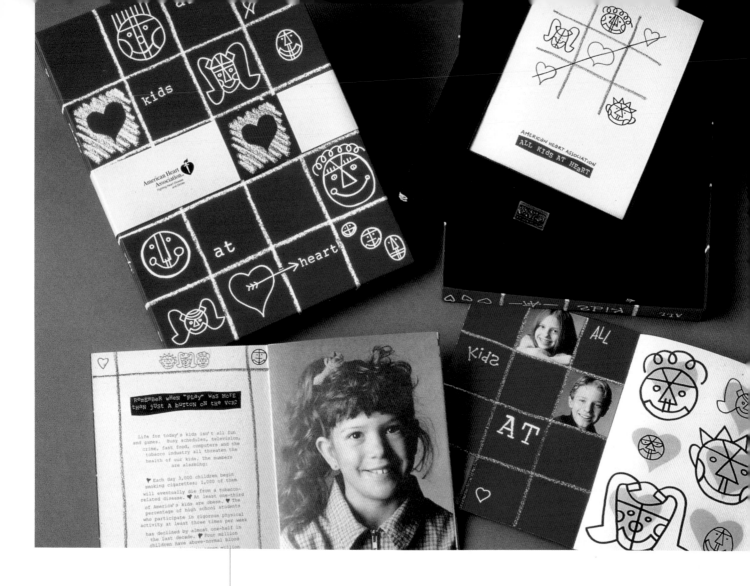

AMERICAN HEART ASSOCIATION ALL KIDS AT HEART FUNDRAISER

Design Firm *Sayles Graphic Design*
All Design *John Sayles*

Once again, red is chosen for impact in this economical two-color fundraising package, a completely appropriate choice for the American Heart Association. The bold graphics, which appear to be hand drawn with crayons, add a playful touch.

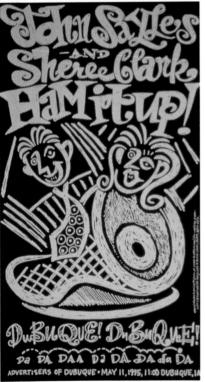

Design Firm *Sayles Graphic Design*
All Design *John Sayles*

Silk screening is an old technique that looks fresh and new in the hands of John Sayles, who frequently employs it. Here, retro-influenced images are silk-screened in black on colored paper.

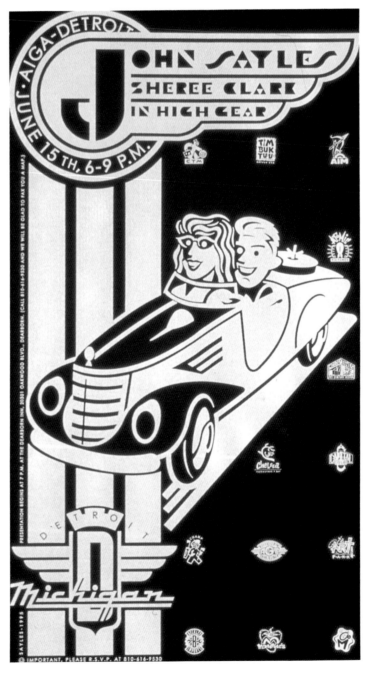

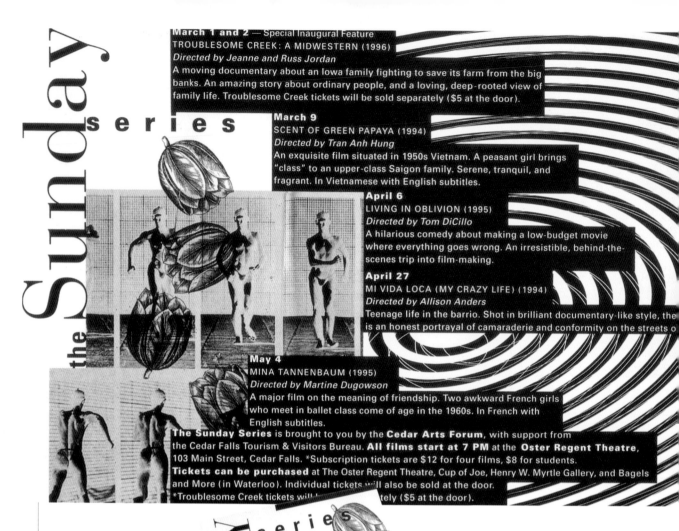

March 1 and 2 — Special Inaugural Feature
TROUBLESOME CREEK: A MIDWESTERN (1996)
Directed by Jeanne and Russ Jordan
A moving documentary about an Iowa family fighting to save its farm from the big banks. An amazing story about ordinary people, and a loving, deep-rooted view of family life. Troublesome Creek tickets will be sold separately ($5 at the door).

March 9
SCENT OF GREEN PAPAYA (1994)
Directed by Tran Anh Hung
An exquisite film situated in 1950s Vietnam. A peasant girl brings "class" to an upper-class Saigon family. Serene, tranquil, and fragrant. In Vietnamese with English subtitles.

April 6
LIVING IN OBLIVION (1995)
Directed by Tom DiCillo
A hilarious comedy about making a low-budget movie where everything goes wrong. An irresistible, behind-the-scenes trip into film-making.

April 27
MI VIDA LOCA (MY CRAZY LIFE) (1994)
Directed by Allison Anders
Teenage life in the barrio. Shot in brilliant documentary-like style, the is an honest portrayal of camaraderie and conformity on the streets o

May 4
MINA TANNENBAUM (1995)
Directed by Martine Dugowson
A major film on the meaning of friendship. Two awkward French girls who meet in ballet class come of age in the 1960s. In French with English subtitles.

The Sunday Series is brought to you by the **Cedar Arts Forum**, with support from the Cedar Falls Tourism & Visitors Bureau. **All films start at 7 PM** at the **Oster Regent Theatre**, 103 Main Street, Cedar Falls. *Subscription tickets are $12 for four films, $8 for students. **Tickets can be purchased** at The Oster Regent Theatre, Cup of Joe, Henry W. Myrtle Gallery, and Bagels and More (in Waterloo). Individual tickets will also be sold at the door. *Troublesome Creek tickets will be sold separately ($5 at the door).

CEDAR ARTS FORUM THE SUNDAY SERIES POSTERS

Art Director *Philip Fass*
Designer *Philip Fass*

Posters and postcards for this project were ganged and printed in black for the ultimate in resourceful, low-cost production. The layering of images, both antique and contemporary, creatively points to the independent films being shown at this festival.

ORANGE
COUNTY

*museum
of art*

ORANGE COUNTY MUSEUM OF ART IDENTITY PROGRAM

Design Firm	*Mike Salisbury Communications*
Art Director	*Mike Salisbury*
Designer	*Mike Salisbury*
Illustrator	*Bob Malle*

This black-and-white identity program is at once elegant and contemporary. It succeeds through the pairing of a distinctive logo, which resembles a coat of arms, with unusual type styles.

ORANGE
COUNTY

*museum
of art*

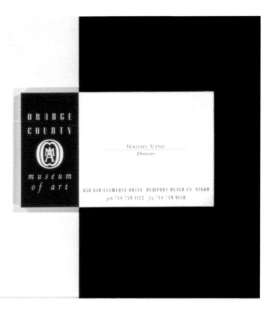

ORANGE
COUNTY

*museum
of art*

850 SAN CLEMENTE DRIVE NEWPORT BEACH CA 92660 ph 714 759 1122 fx 714 759 5625

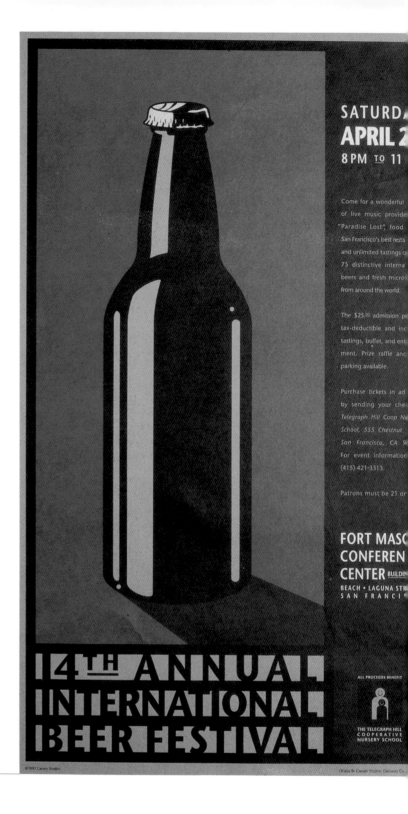

TELEGRAPH HILL COOPERATIVE NURSERY SCHOOL
BEER FESTIVAL POSTER

Design Firm *Canary Studios*
Art Directors *Carrie English, Ken Roberts*
Designer *Carrie English*

The use of screen tints makes this poster and postcard
for a fundraising beer festival richer and more
distinctive than one would expect from a two-color
design. The strong, clear, minimal illustration and type
strengthens the effect.

MOONDOG STUDIOS HOLIDAY GREETING CARD

Design Firm	*Moondog Studios, Inc.*
Art Directors	*Odette Hidalgo, Derek von Essen*
Designers	*Odette Hidalgo, Derek von Essen*

An irreverent, unexpected holiday sticker that formulates a new symbol of the season: the karma chicken. Printed in two colors, the stickers were applied to all the gifts and cards the company sent out during the season.

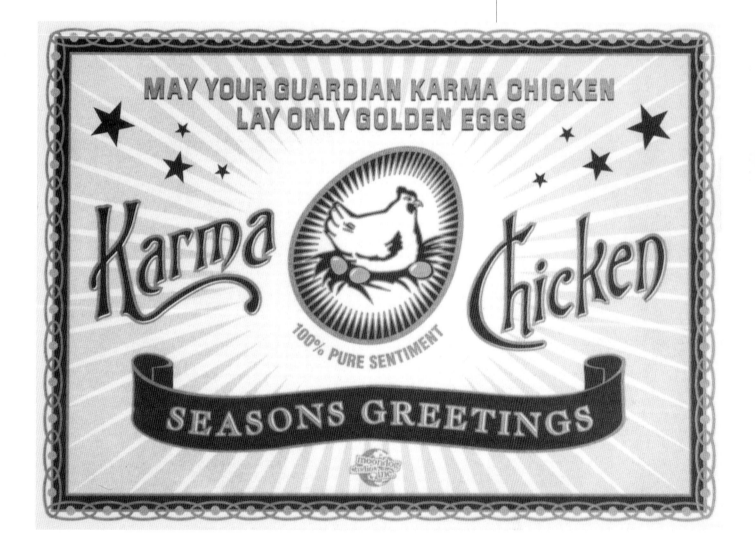

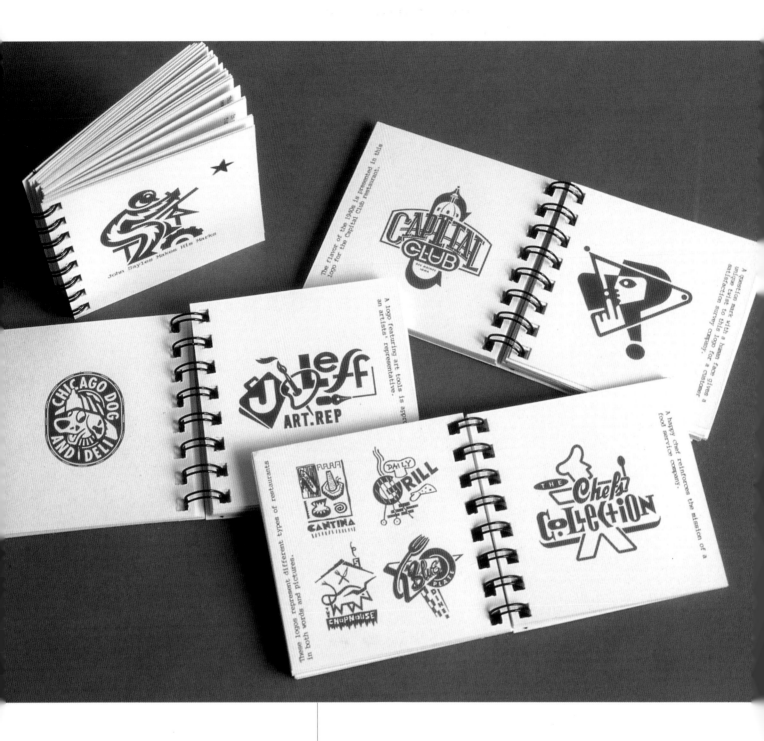

SAYLES GRAPHIC DESIGN LOGO BOOK

Design Firm | *Sayles Graphic Design*
All Design | *John Sayles*

When the image is the message, there's no need for elaborate color. This book, which features the numerous logos John Sayles has designed for corporate clients, is printed in one color with a typeface that looks like it came from a vintage typewriter.

CANARY STUDIOS PROMOTIONAL CAMPAIGN

Design Firm | *Canary Studios*
Art Directors | *Carrie English, Ken Roberts*
Designers | *Carrie English, Ken Roberts*
Illustrator | *Carrie English*

Using prefabricated mailing boxes that are in themselves a promotional greeting made loads of sense—and are even more economical when printed in black. Gifts inside align with copy—for example, with matches, copy refers to sparking and igniting sales.

HAL APPLE LETTERHEAD AND BUSINESS CARD

Design Firm	*Hal Apple Design & Communications, Inc.*
Art Director	*Hal Apple*
Designers	*Alan Otto, Jason Hashmi, Andrea Del Geurico, Hal Apple*

The die cutting of the letter *A* in this letterhead and business card is made possible by the use of one-color printing throughout the identity program. This project is an excellent example of the way colored paper can enrich a simple, one-color design.

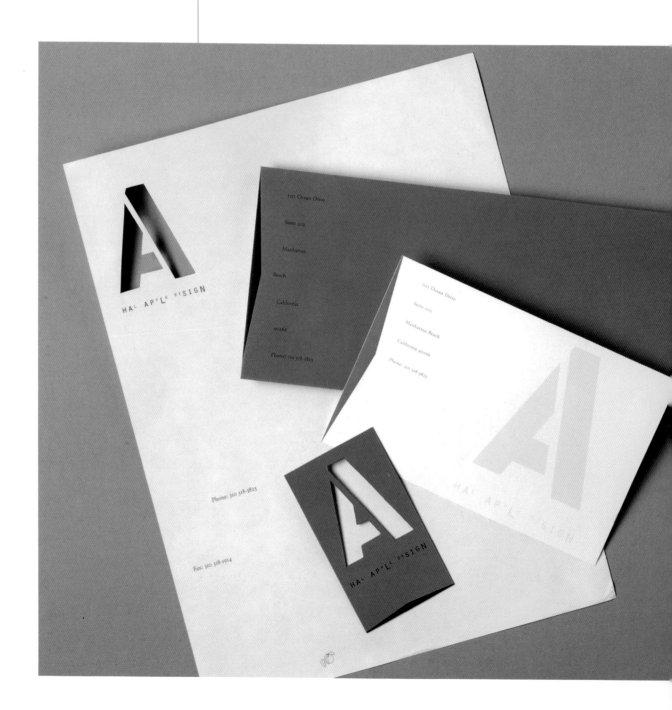

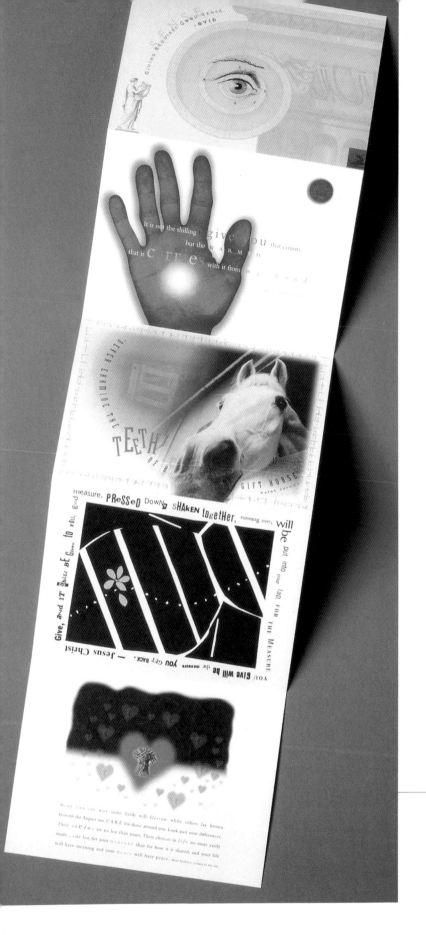

HAL APPLE HOLIDAY DIRECT-MAIL PROMOTION

Design Firm *Hal Apple Design & Communications, Inc.*
Art Director *Hal Apple*
Designers *Alan Otto, Jason Hashmi, Rebecca Cwiak, Andrea Del Geurico, Hal Apple*

This evocative holiday direct-mail promotion proves that content and imagination triumph over cost. Printed in one color, the designers used clipart and screen tints to give the piece its rich, multidimensional feel.

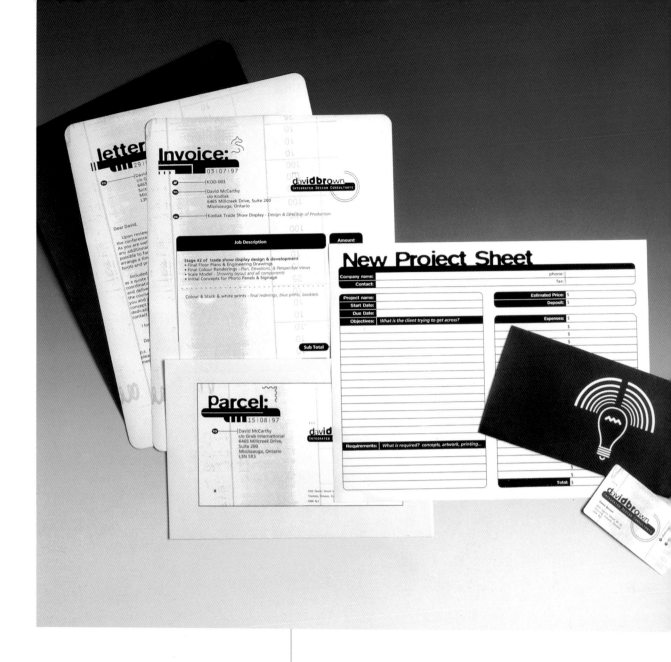

**DAVID BROWN INTEGRATED DESIGN
CONSULTANTS IDENTITY PROGRAM**

Design Firm | *David Brown Integrated Design Consultants*
Art Director | *David Brown*
Designer | *David Brown*

This snappy, no-nonsense identity program relies upon
the use of bold type and a technological-looking
screened image for interest and texture. The brochure,
business forms, and letterhead are economically printed
on a laser printer.

CEARNS & BROWN PACKAGING

Design Firm | Wolff Olins
Creative Director | Lee Coomber
Designers | Phil Rushton, Kerry Humphreys, Sam Wilson
Photographer | Mike Russell
Illustrator | Pete Denmark

Plain wrapping at its most utilitarian—and pleasing. The choice of Pantone 343 green and a bright-white stock, plus a typeface that is simplicity itself, creates a clear space in which photography of the product inside becomes the focus of the consumer.

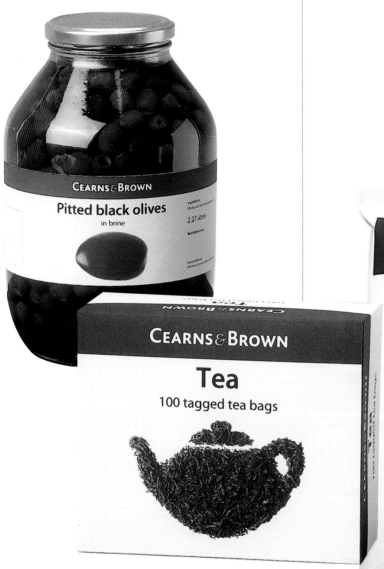

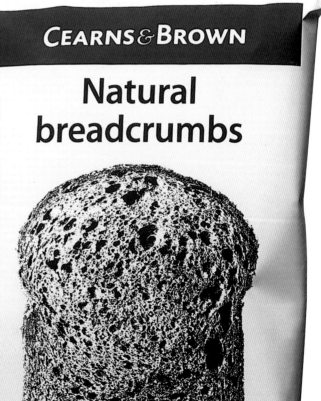

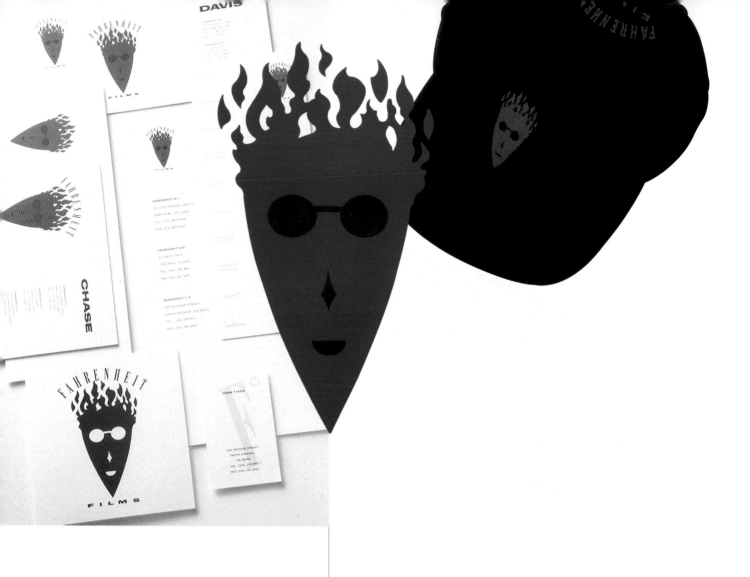

FAHRENHEIT FILMS IDENTITY PROGRAM

Design Firm | *Jay Vigon Studio*
Creative Director | *Jay Vigon*

A devilish, bright-red logo implies the nature of feature
film production—this company is literally on fire
creatively. The logo is so strong it even looks great
printed in black; in its two-color version, it enlivens
the company's simple, relatively inexpensive
stationery package.

PRETTY GOOD PRIVACY SOFTWARE LOGO

Design Firm | Hornall Anderson Design Works Inc.
Art Director | Jack Anderson
Designers | Jack Anderson, Debra Hampton, Heidi Favour,
Jana Wilson, Katha Dalton, Michael Brugman

This bold black-and-white logo says everything graphically. A stylized rendering of a profile behind a shade, the logo was designed for a software company whose encryption software ensures e-mail can't be intercepted online.

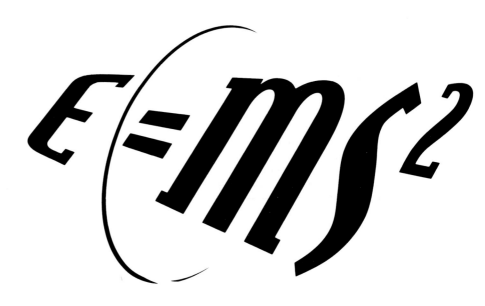

VICES & VIRTUES/IVILLAGE, INC. WEB SITE LOGO

Design Firm *Duffy Design*
Design Director *Neil Powell*
Designer *Lourdes Banez*

The designer chose red for the logo of this adult-oriented Web site, not just for its eye-catching quality but because it is the most obviously naughty color in the spectrum.

MICROSOFT CORPORATION $E = MS^2$ CONFERENCE LOGO

Design Firm *Hornall Anderson Design Works Inc.*
Art Director *Jack Anderson*
Designers *Jack Anderson, John Anicker, Mary Chin Hutchison*

This logo for a conference held by Microsoft was designed as a take-off on Einstein's theory of relativity: $E = MC^2$. The logo feels like it is receding into the background and the unusual typeface gets larger on the right side, as it passes through a translucent lens that implies transformation.

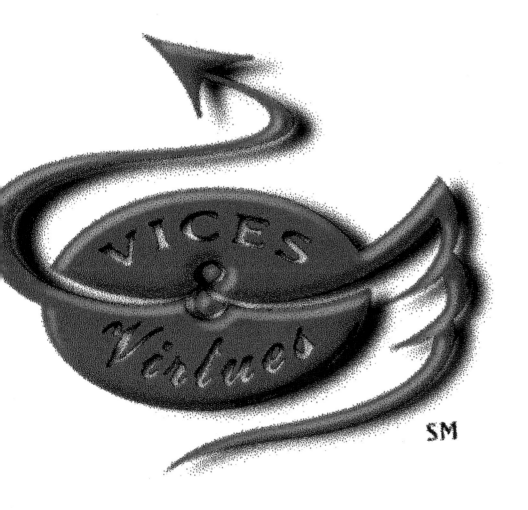

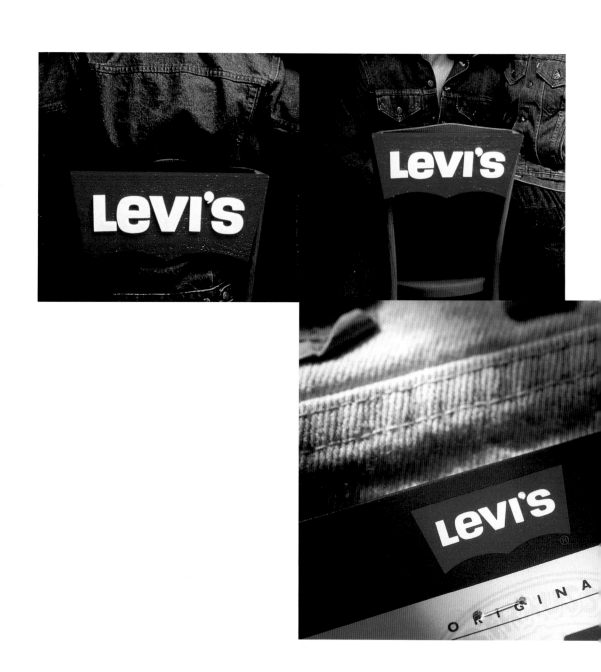

?INTERACTIVE BUREAU!

INTERACTIVE BUREAU LOGO

Design Firm | Interactive Bureau
Creative Director | Roger Black
Designer | Roger Black

This bold logo is yet another entry in the red-and-black, Constructivist style favored for its strong visual qualities. When animated on its Web site, however, it rotates, moving from question mark to exclamation point and back again.

LEVI STRAUSS LOGO

Design Firm | Landor Associates

Clear, direct, and up to date, this logo for Levi Strauss, the world's largest apparel manufacturer, includes the demanding color red with plain white block type. The shape of the logo is taken from the rear-pocket stitching of Levi's jeans.

BROOKLYN ACADEMY OF MUSIC POSTCARDS

Design Firm | *BAMdesign*
Designers | *Rafael Weil, Jason Ring*
Photographs | *Corbis Archive*

Strong stock photography is enhanced with a limited
but emotional use of color in these mailers for a
cutting-edge arts organization. The result is a piece
that is inexpensive to produce but high in impact.

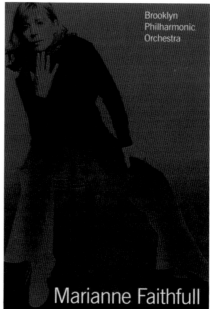

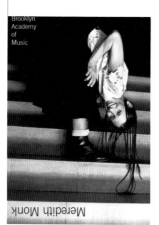

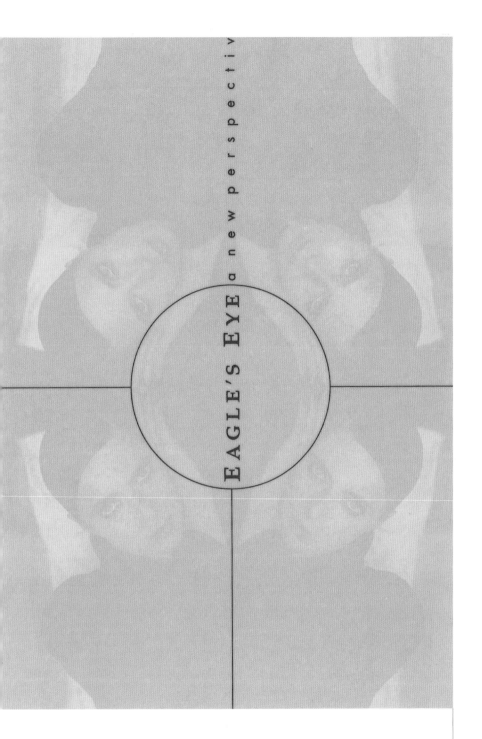

EAGLE'S EYE IMAGE BOOK

Design Firm	*Socio X*
Creative Director	*Deborah Moses*
Art Director	*Bridget De Socio*
Designer	*Albert Lin*
Photographer	*Ruven Afanador*
Digital Imager	*Ninja Von Oertzen*

Elaborately produced with primarily black-and-white images that have been digitally drawn into mandala-like multiples, this persuasive direct-mail marketing piece from clothing firm Eagle's Eye reinforces the idea of cool, comfortable, contemporary chic.

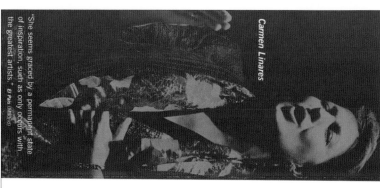

Brooklyn
Philharmonic
Orchestra

30 Lafayette
Avenue
Brooklyn NY
11217-1486

NON PROFIT
ORGANIZATION
US POSTAGE
PAID
BROOKLYN NY
PERMIT #7368

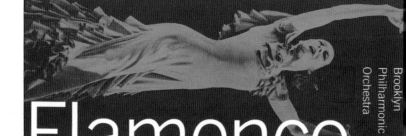

BROOKLYN PHILHARMONIC ORCHESTRA
DIRECT-MAIL PIECE

Design Firm *BAMdesign*
Art Director *Rafael Weil*
Designer *Jason Ring*

This direct-mail piece employs two-color
images and type, plus an unconventional vertical
format, to remind subscribers of an upcoming flamenco
weekend at the Brooklyn Academy of Music.

UBU GALLERY EXHIBITION PROMOTION

Design Firm | *Boxer Design*
Creative Director | *Michael Baviera*
Art Director | *Eileen Boxer*
Designer | *Eileen Boxer*

This Manhattan gallery has found a way to fuse the pragmatic (simple black-and-white design and inexpensive materials) with the sublime (each piece is a keepsake) for its exhibition mailings.

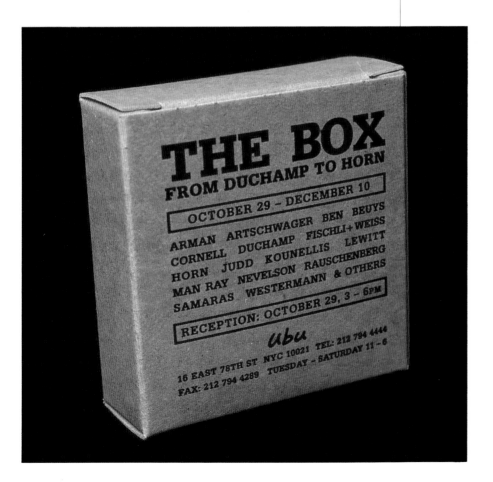

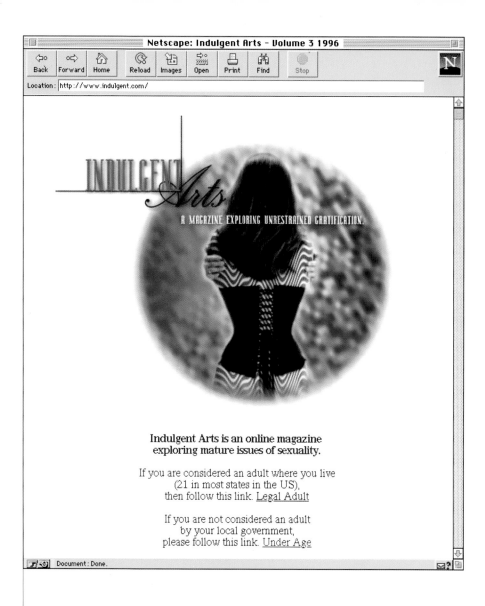

Indulgent Arts is an online magazine
exploring mature issues of sexuality.

If you are considered an adult where you live
(21 in most states in the US),
then follow this link. Legal Adult

If you are not considered an adult
by your local government,
please follow this link. Under Age

INDULGENT ARTS WEB SITE
www.indulgent.com

Design Firm	*C.A.P.*
Designer	*Rhonda Anton*
Illustrator	*Rhonda Anton*
Photographer	*Eileen Boxer*
Programmer	*Eileen Boxer*

The initial image that comes up for *Indulgent Arts*
magazine, an adult-oriented online magazine, is a
grayscale preview. Along with the curvy, traditional
seriph-style typefaces, this restrained image is designed
to alluringly lead the viewer deeper into the magazine.

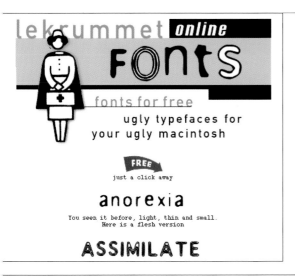

fonts for free

ugly typefaces for
your ugly macintosh

FREE
just a click away

anorexia
You seen it before, light, thin and small.
Here is a flesh version

ASSIMILATE

LEKRUMMET WEB SITE
ww.ot.se/lekrummet

Design Firm *Lekrummet Design*
Designer *Jorgen Joralv*
Programmers *Jorgen Joralv, Alex Picha*

This design firm employs a deliberately utilitarian, highly simplified look reminiscent of 1920s Bauhaus design in their Web site. The limited color palette makes the site fast-loading and the occasional use of a vibrant red makes the viewer take notice.

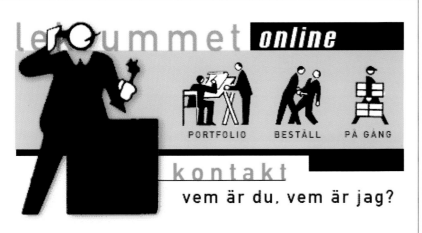

PORTFOLIO BESTÄLL PÅ GÅNG

kontakt
vem är du, vem är jag?

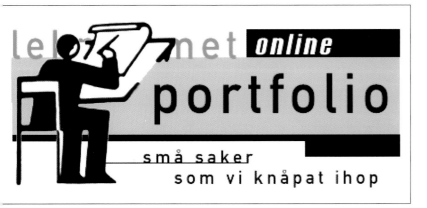

portfolio

små saker
som vi knåpat ihop

directory